IMAGES
*of America*

# LIVONIA

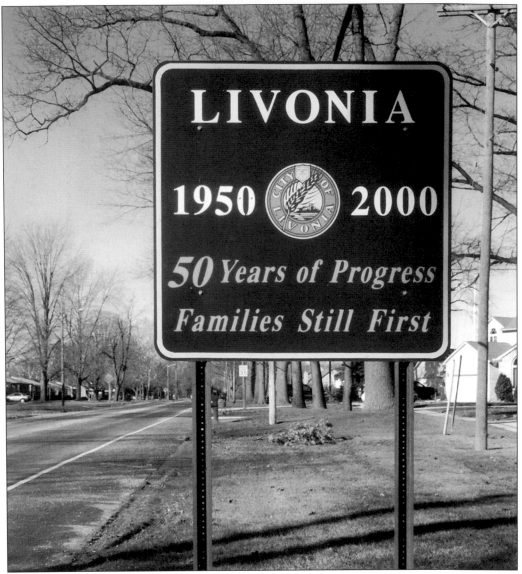

Livonia's motto of "Families Still First" is an accurate reflection of the community's priorities. The city has consistently striven to be a suburban ideal with an emphasis on schools, parks, and housing. The ear of wheat on the city seal serves as a reminder of the city's farming past.

IMAGES
*of America*

# LIVONIA

David MacGregor

ARCADIA

Published by Arcadia Publishing
Charleston SC, Chicago IL, Portsmouth NH, San Francisco CA

Printed in the United States of America

Library of Congress Catalog Card Number: 2005924316

For all general information contact Arcadia Publishing at:
Telephone 843-853-2070
Fax 843-853-0044
E-mail sales@arcadiapublishing.com
For customer service and orders:
Toll-Free 1-888-313-2665

Visit us on the Internet at http://www.arcadiapublishing.com

*I would like to dedicate this book to my parents, Morris and
Euphemia, who came to Livonia in 1959. And also to Louise, the
best thing to come out of Livonia since Velvet Peanut Butter.*

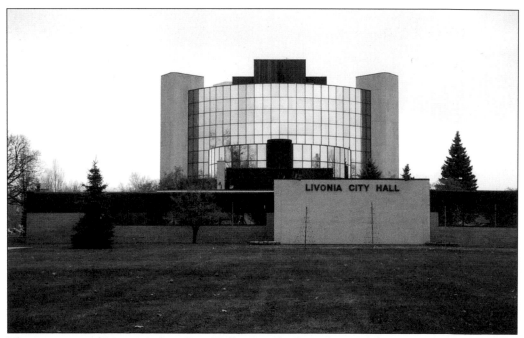

The remnants of Livonia's first City Hall sit modestly in front of the more postmodern new
City Hall.

# CONTENTS

# ACKNOWLEDGMENTS

This book was really a community effort, with many people graciously providing a wide variety of material and information. These include Nick Mladjan, Kim Kovelle, Richard Weinert, Dorene O'Brien, Scott Grace, David Tinder, Al Buchfinck, and Dave Varga from the *Livonia Observer* newspaper. From the City of Livonia, Karen Kapchonick, Cathy Condon, Rondi Anderson, and Marian Renaud were all especially thoughtful and helpful. I would also like to thank Valerie Latzman from the Wayne Historical Museum and Elizabeth Kerstens of the Plymouth Historical Museum for their insights and access to their archives. Most of all, my eternal gratitude goes to Sue Daniel for her unfailing knowledge, guidance, and wisdom. Livonia is very fortunate to have a person like Ms. Daniel, whose passion for history and devotion to Greenmead Historical Park are truly an inspiration.

Finally, thanks to my children, Torin and Kelsey, for their patience and splendid company as we roamed around Wayne County collecting material for this book.

# INTRODUCTION

The history of Livonia is really a tale of two cities. On the one hand, Livonia is the quintessential bedroom community, notable for its neighborhoods, parks, and the quality of its public schools. But beneath this placid exterior lies a quite different city—one notable for its role in the Underground Railroad, as well as being used as a playground by Prohibition-era gangsters, not to mention being a hotbed for grave-robbing in the 19th century. And was Livonia really bombed by the Japanese during World War II, as reported by the *Detroit Free Press?* Suffice to say, there is more to Livonia than meets the eye.

Prior to the arrival of white settlers, the Livonia area was inhabited and fought over by a number of Indian tribes—the Wyandottes, Sauk, Miami, and Potawatomi in particular. Subsequently, the French and Indian War saw the French and the British fighting for control of the region, and when the Treaty of Paris ended the American Revolution in 1783, this area became known as the Northwest Territory of the United States of America. With the signing of the Treaty of Detroit in 1807, the Native Americans effectively sold their rights to most of the land in what was to become Livonia; this cleared the way for settlers to start moving in, although there were still a number of Native Americans in the area.

The first recorded purchase of land in what would become Nankin Township was by Dennison Palmer on November 7, 1818, although there is no evidence that he ever settled here. In early 1819, William Woodbridge (who later became governor of Michigan) purchased some property as well. That same year, Chief Tonquish, leader of the Potawatomi tribe, was killed by a settler in a dispute over bread and the Potawatomis subsequently abandoned this region altogether. With land priced at only $1.25 per acre, more and more pioneers made the trip up the Rouge River from Detroit, stopping and claiming land where they saw a good place to farm and establish a homestead. With the completion of the Erie Canal in 1825, Easterners were now more easily able to heed the cry of "Go West, young man," and a number of ambitious and daring families packed up their belongings and headed for Michigan.

In 1827, the area now comprising Livonia, Redford, Dearborn, Dearborn Heights, Inkster, Garden City, Westland, and Wayne was simply known as Bucklin Township (named after William Bucklin, who was a justice of the peace). In 1829, Bucklin was divided into two sections: Nankin to the west and Pekin to the east. Both were named for the Chinese cities where a good deal of well-advertised missionary work was in progress. Six years later, on March 17, 1835, the Township of Livonia split off from Nankin and took its current 36-square-mile form. This was two years before Michigan became a state in its own right. The name Livonia

was chosen because a number of the earliest settlers had come from western New York, where there was also a town named Livonia.

The original Livonia was once an Eastern European nation unto itself, although its territory was usually under some kind of dispute. In fact, Livonians in Europe found themselves being ruled by Poland, Sweden, and Russia at various points in history. In 1243, a host of Livonian knights was defeated in the Battle on Lake Peipus by an army from Novgorod commanded by Alexander Nevsky, an episode immortalized in Sergei Eisenstein's 1938 film, *Alexander Nevsky*. With Riga as its largest city and capital, Livonia contained over 1,000 lakes and it was long known as one of the three Baltic provinces of Russia. Today, the original land of Livonia is split between Latvia and Estonia and the last remnants of the Livonian language are on the verge of dying out.

Meanwhile, here in Michigan, growth in this latest namesake of Livonia was sporadic. In 1840, the township had 1,169 people listed in the United States Census and by 1880 this had increased to 1,638 people. However, in the 1920 census, the population of Livonia had actually declined to 1,608. All of this was about to change, in large part due to improvements in transportation and roads. White-collar workers from Detroit's auto industries increasingly looked to the suburbs as places they wanted to raise their families. In 1915, the Horton subdivision was established at Newburg, and in 1925, building began in two of Livonia's best-known subdivisions, Coventry Gardens and Rosedale Gardens.

However, it wasn't the neighborhoods that prompted the Township of Livonia to become a city. That came about largely due to the arrival of the General Motors Hydra-Matic plant in 1948 and the Detroit Race Course in 1949. Both represented significant tax windfalls if the township became a city, and on May 23, 1950, Livonia did precisely that. It was a momentous decision, because in 1950, the population of Livonia stood at 17,534. But with the relatively low property taxes offered to both businesses and residents, the population rose to 66,702 by 1960 and surpassed 100,000 by 1970—a population size that has remained reasonably stable ever since.

Today, Livonia is routinely rated as one of the safest cities in the United States and one of the best places to raise a family as well. Most residents are grateful for the parks, golf courses, ice rinks, and so on, but few recall or even know of its rural past, where every road was dirt and the township was best known for its cheese factories—which, combined, churned out hundreds of thousands of pounds of cheese every year. This volume is intended to serve as a window into that past and a testament to the pioneers who had the vision and the will to turn 36 square miles of wilderness into the flourishing city that Livonia is today.

# One

# 1800–1850

The Rouge River was known as "minosagoink" (a place to go nicely) and "mishqua sibe" (red river) to the Potawatomi people. It is the Middle Rouge branch that runs through the southern portion of Livonia alongside Hines Drive. Just as it attracted Native Americans to the area, it was the pathway used by early settlers who began their journeys in Detroit and followed the river west until they found land to their liking.

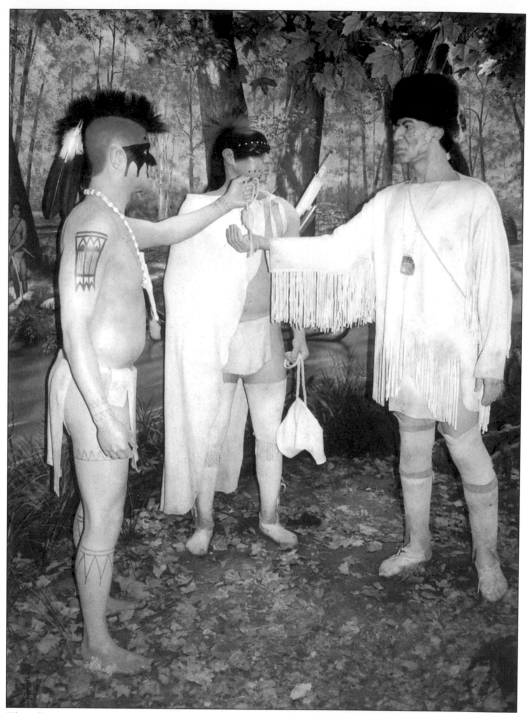

This diorama at Nankin Mills depicts members of the Potawatomi tribe, which inhabited the Livonia area prior to the arrival of white settlers. The Rouge River served not only as a "road" for travel and trade—the fertile flood plain surrounding it was ideal for hunting and farming, the primary crops being corn, squash, and beans. In the Treaty of Detroit (1807), the Potawatomi gave up much of their land in this area, clearing the way for settlers to start moving in.

## MICHIGAN REGISTERED HISTORIC SITE

# LIVONIA REVOLUTIONARY WAR VETERANS

This marker commemorates three American Revolutionary War soldiers who lived and died in Livonia. David Dean was born in 1763 and enlisted in the New York militia in 1778. Dean settled in Livonia around 1836 where he died in 1838. A native of Connecticut, born in 1755, Salmon Kingsley belonged to a company of minutemen who aided in the defense of Boston. Kingsley came to Livonia in 1825 where he died two years later. Born in New York about 1763, Jeremiah Klumph was a messenger in Washington's army. Klumph lived in Livonia from 1836 until his death in 1855. These men were a few of the many Revolutionary veterans who settled in the west. All three journeyed with their families and settled in this area.

MICHIGAN HISTORY DIVISION, DEPARTMENT OF STATE
REGISTERED LOCAL SITE NO. 385
PROPERTY OF THE STATE OF MICHIGAN 1976

It comes as a surprise to many Livonians to learn that veterans of the American Revolutionary War lived and died here. This historical marker at Bicentennial Park briefly recounts the lives of David Dean, Salmon Kingsley, and Jeremiah Klumph, all of whom fought for this country's independence.

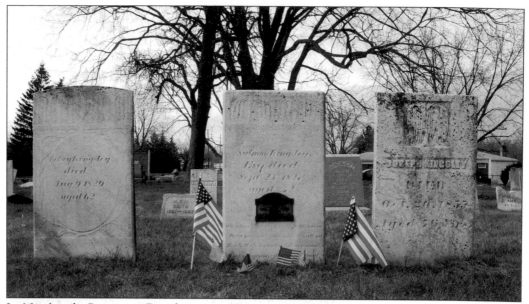

In Newburgh Cemetery, Revolutionary War veteran Salmon Kingsley is buried between his wife, Betsey, and their son, Joseph. Salmon was born in Connecticut in 1755, and when he died in 1827, he was buried on his own land. This is the first recorded burial in Livonia. In 1832, his son, Joseph Kingsley, donated this plot of land to the community for use as a cemetery. (Courtesy of Torin MacGregor.)

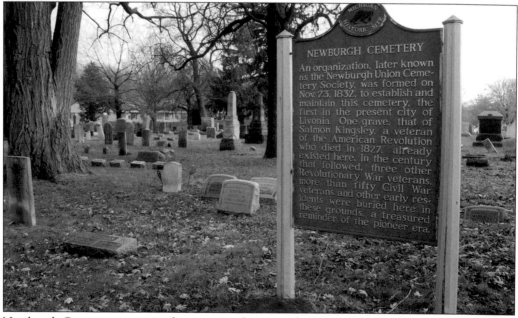

Newburgh Cemetery contains the remains of many early Livonia pioneers, as well as veterans of the Revolutionary War, the War of 1812, and the Civil War. Established in 1832 for the grand total of $41.90, lots here were priced at 50¢ each. Originally 1.38 acres, the site now comprises 2.35 acres and is located on Ann Arbor Trail between Wayne and Newburgh Roads. In 1905, cemetery sexton James Rawson was suspected of misappropriating funds, but instead of facing the charges, he burned all of the records and then proceeded to slit his own throat.

Joshua Simmons III was born in Massachusetts in 1801 and his family subsequently moved to Bristol, New York. In 1824, with a grant signed by President John Quincy Adams, Simmons bought 160 acres of land in what would become Livonia Township. He and his wife, Hannah, had seven children and built a farm they called Meadow Brook on their land at the corner of Newburg and Base Line Roads. By 1850 Simmons was the wealthiest farmer in Livonia, raising wheat, oats, corn, and sheep. He contributed to the founding of the Union Church of Livonia in 1850 and reputedly cleared approximately 120 acres of land before his death in 1882 at age 81.

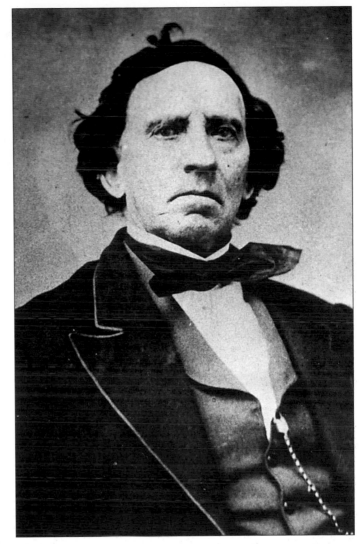

NOTE: Livonians have long been curious about the variation in the spelling of "Newburgh" and "Newburg." In 1890, the U.S. Board on Geographic Names declared that in the interest of consistency, all American cities and townships ending in "burgh" must drop the final "h." Following years of protests, the board reversed its decision in 1911 and the letter "h" was added to names like "Newburg." Livonia's Newburg retained its original spelling until the 1950s, when fresh waves of new residents assumed it was spelled with an "h," as other "burghs" around the country were spelled, and it is now spelled "Newburgh."

Hannah Macomber Simmons and her husband, Joshua, came to Livonia in 1826. Their first home was a log cabin, and in 1841 they built a farmhouse in the Greek Revival Style. It was regarded as the finest farmhouse in Wayne County. Hannah Simmons died in 1894 at 88 years of age.

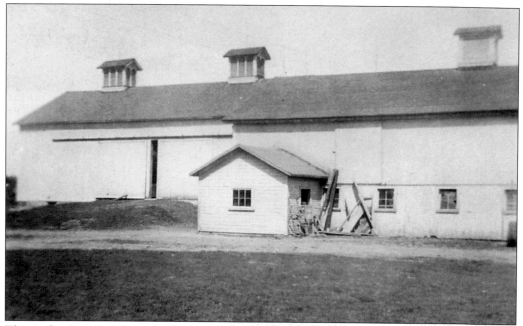

This is the Simmons barn, built in 1829 by Joshua Simmons III, who was an expert at hewing the lumber which helped build the first barns and mills in Livonia and its surrounding communities. The barn still stands at Greenmead Historical Park.

14

On November 18, 1827, Richmond Simmons became the first white male born in Livonia. He was the eldest son of Joshua Simmons III. Richmond married Huldah Power, his next-door neighbor, and they had four children. Together, they worked their farm on Ten Mile Road. He died in Novi Township in 1902.

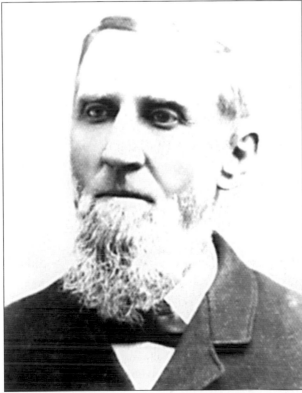

Lawrence Simmons (1829–1918) was a cooper (barrel-maker) who had his own farm on Twelve Mile Road. When his father, Joshua, retired, he took over the Meadow Brook Farm, which was subsequently passed down to his daughter and then his grandson. In 1920, Sherwin and Jean Boyd Hill bought the farm, by which point it was known as Greenmead. In 1976, the City of Livonia acquired the property and today the former Simmons Farm is the location of Greenmead Historical Park.

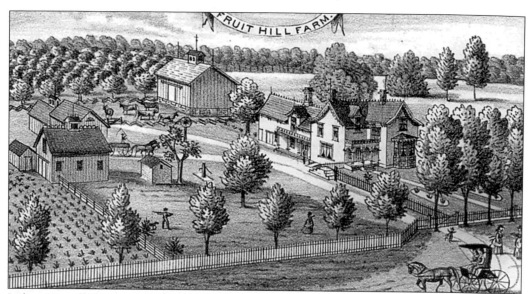

Joshua Morrell Simmons (1833–1911), the youngest son in the Simmons family, built Fruit Hill Farm right next door to his father's Meadow Brook Farm, just west on Base Line Road. A number of drawings, like this one, accompanied the *Illustrated Historical Atlas of Wayne County* published in 1876. They showed a variety of the farms and orchards that comprised Livonia at that time.

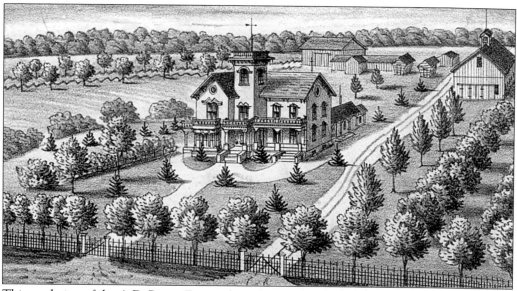

This rendering of the A.D. Power Farm is from the same series as above. The Power Farm would later include the biggest cheese factory in Livonia. The land was eventually acquired by the city and is now the location of Whispering Willows Golf Course.

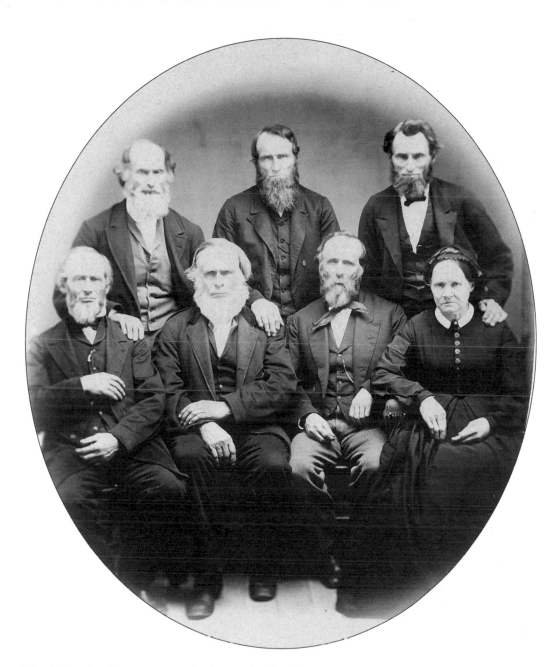

The Briggs family was among the largest landholders in Livonia in the 19th century, and this portrait shows a portion of the family. In back, from left to right, are Luther, Lewis, and Carmi. In front are Dexter, John Pardon, Warden, and Betsy. Dexter Briggs (1804–1892) was the first family member to arrive, coming from Niagara County, New York, in 1826. He purchased 80 acres of farmland at what is now the intersection of Newburgh and Seven Mile Roads. In addition to his farming duties, he also served as constable, highway commissioner, and township assessor. Born in 1828, Carmi Briggs was the youngest of the seven Briggs brothers and he arrived in Livonia with his parents in 1830. After his first wife died in 1858, he married Ann Shaw, with whom he worked 165 acres of farmland on Six Mile Road east of Newburgh. He died on October 29, 1875, of typhoid pneumonia at age 47.

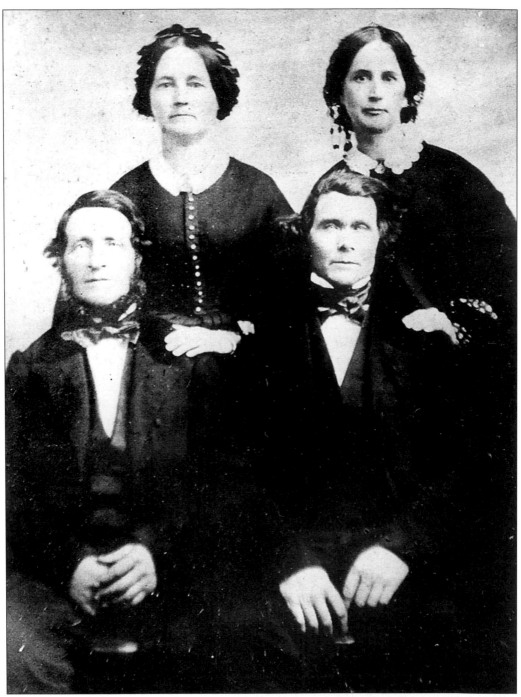

The Ryder family were among Livonia's earliest pioneers, coming from the state of New York. David Ryder and his wife, Polly Bain Ryder, purchased 80 acres and built a log cabin home in 1827. They had four sons and four daughters. Pictured here are two of their sons, George (on the left, with his wife, Henrietta Vinton), and John (on the right, with his wife, Adarima Eldridge). George and Henrietta were married in 1840 and built a large home on Plymouth Road in 1856. Their two sons, Alfred and John, were both killed in 1863 at the Battle of Gettysburg.

Marcus Swift (1793–1865) was born in Palmyra, New York, and bought land in 1825 in what was then Bucklin Township. He and his wife, Anna, had four children: Osband, Hannah, George, and Orson. Along with being Nankin Township supervisor and a justice of the peace, Swift was also an ardent and relentless abolitionist. He was the founding pastor of Newburg Methodist Church in 1834 and he is buried in Newburgh Cemetery.

The Newburg Methodist Church has a long and somewhat stormy history, in large part due to divergent views on the morality of slavery. In 1841, Newburg Reverend Marcus Swift split off from the church over this issue, soon joining other like-minded individuals to form the Wesleyan Methodists. Ironically enough, he died on February 19, 1865, less than two months before the Civil War ended.

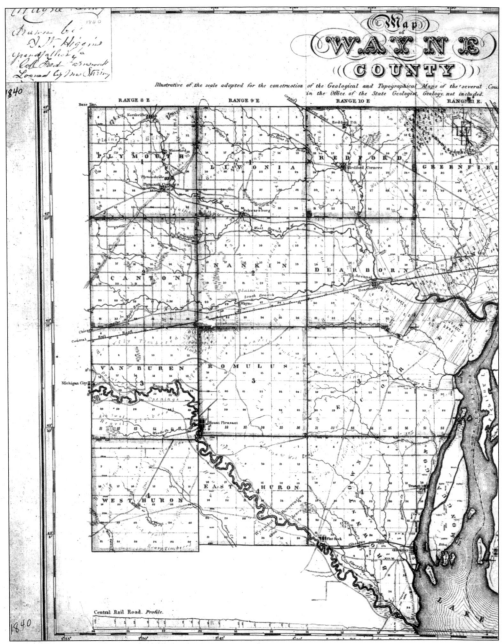

This map of Wayne County from 1840 shows what Livonia looked like five years after it became a township. The land has been broken up into 36 sections of one square mile each, an organizational system that is still used today. At this point, the most salient features of the township are the community of Schwarzburg, in the southern portion, and two rivers. Belle River splits off into Briggs Creek and Collins Creek, and the west branch (later renamed Middle Rouge) of the Rouge River is identified as well. The road running through Schwarzburg was known as Territorial Road (today's Ann Arbor Trail). Much of the township is described as "heavily timbered." The Tonquish Plains south of the Rouge were named for Chief Tonquish, a Potawatomi Chief who was killed by settlers in 1819. (Courtesy of the Wayne Historical Museum.)

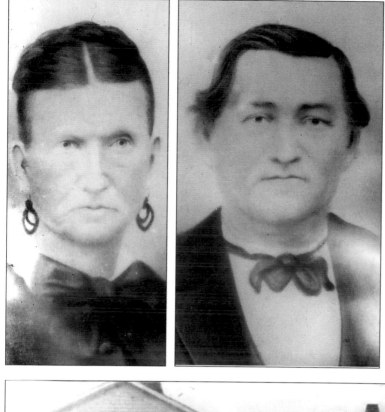

Phineas Wilson (1803–1875) and his wife Louisa (1810–1890) arrived in Livonia in 1836 with Louisa's father, Jeremiah Klumph, who had served as a messenger in George Washington's army as a young man. Phineas had been born in Vermont and Louisa was born in the state of New York. They were married in Portland Township, New York, on August 13, 1829. Although the family lived in Livonia, Phineas would walk to work in Detroit every week, coming home only on the weekend.

This is the home of Phineas and Louisa Wilson c. 1860. It was on Middlebelt Road, just south of West Chicago. They had four sons to help them work the farm: Walter (1832–1911), Jeremiah (1835–1908), Erastus (1843–1912), and Norman (1852–1933).

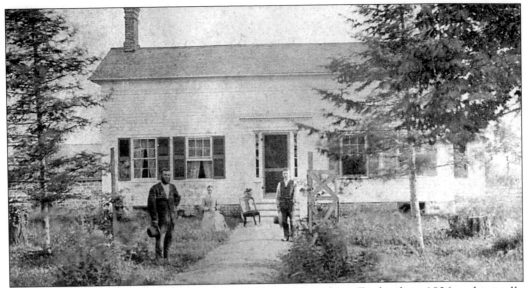

Thomas Shaw came to Livonia from Wysall, Nottinghamshire, England, in 1836 and initially took up residence in a log cabin. This frame home, built in 1843, was one of the first frame houses built in Livonia. Thomas Shaw died in 1844 and his youngest son, John (1824–1916), took over the farm at age 20. This 1876 photograph shows John Shaw with his second wife, Myra Hodge (1836–1911), and his son, William (1859–1928), from his first marriage. Located on Six Mile Road near Haggerty, the house was in the path of the proposed I-275 expressway and was subsequently moved to Greenmead Historical Park.

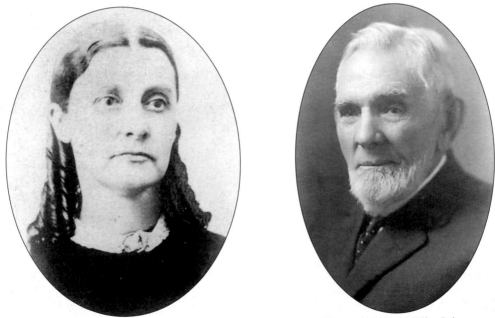

John Shaw is pictured with his first wife, Mary Ann Shaw (1830–1875). John was a hard-working, very prosperous farmer. When he took over his father's farm in 1844, it measured some 80 acres. By 1893, the Shaw Farm encompassed no less than 260 acres.

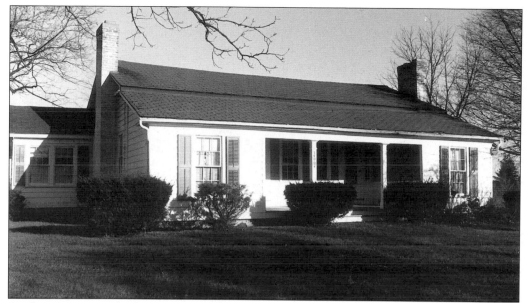

Quaker Acres was built in 1846 and served to replace a Quaker meeting house that had been built in the early 1830s by the large number of Quakers who had moved to the Livonia area. One of those was Nathan Aldrich, who arrived here from Farmington, New York, and purchased all of Section 5 on June 17, 1824. The structure had two front doors, one for men and one for women, who sat separately during services. In December of 1961, the City of Livonia purchased the property for $23,550.

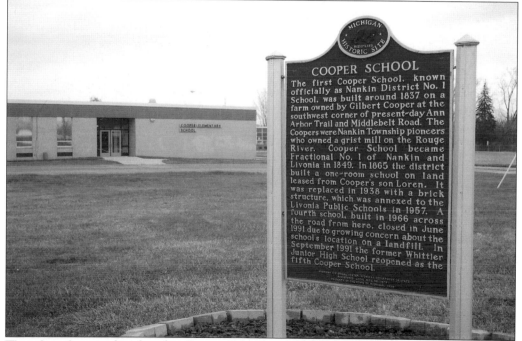

There have been no less than five Cooper Schools associated with Livonia, the first version being built in 1837 on Gilbert Cooper's farm. This most recent incarnation is actually located just south of Livonia in Westland, but it is still considered to be part of the Livonia Public Schools.

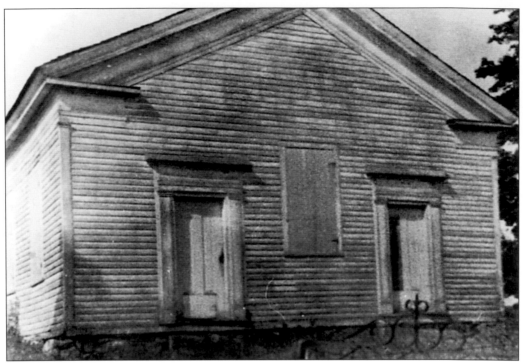

This Union Meeting House was built on Six Mile Road in 1850. The building was intended for non-denominational religious ceremonies (often made up of Quakers, Baptists, and Congregationalists), as well as lectures and other assorted community uses. Backed by well-heeled pioneers like Joshua Simmons, John Shaw, and the Briggs family, it served this function until the 1930s, when it was closed. Today this building serves as the home of Trinity House Theatre.

Nestled behind the former Union Meeting House is the Union Cemetery, a small dab of land between an Italian restaurant and a day care center. Many of Livonia's earliest pioneers were laid to rest here, including one Civil War veteran, although the earliest marker dates back to 1832.

# Two

# 1850–1900

The Fugitive Slave Bill of 1850 made it dangerous for runaway slaves to stay in urban centers in the North. Therefore, more slaves continued on to Canada in the aftermath of this bill. A number of Livonia homes were part of Michigan's Underground Railroad, which operated from 1829 until 1862. Not surprisingly, few records were kept of this enterprise, but the Middle Rouge River was a popular route for getting escaped slaves to Detroit, and then across the border to Canada. Houses or other resting points were referred to as "stations" and located every 15 miles or so along the route. The "station-keepers" were usually Quakers and abolitionists.

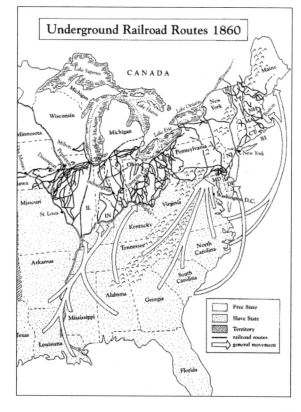

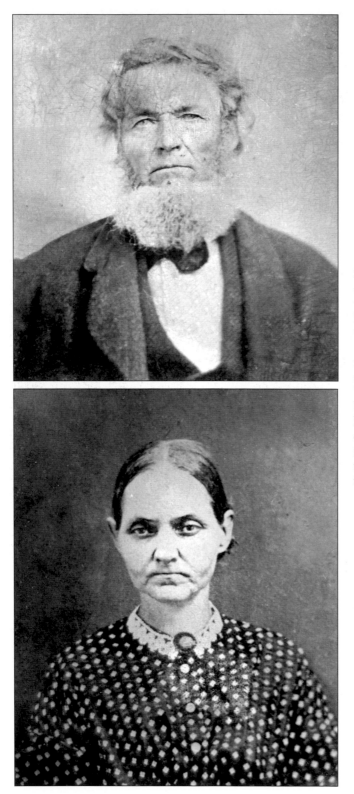

Samuel B. Smith was born on April 17, 1804, and his wife Nancy E. Hammon was born on April 1, 1817. They were married on April 28, 1839. Smith owned a cheese factory on Six Mile Road, was a justice of the peace, and by all accounts was a genial, beloved man who was generally known as Squire Smith. His cheese factory was eventually taken over by Otto Ziegler (the father of Jesse Ziegler, Livonia's first mayor).

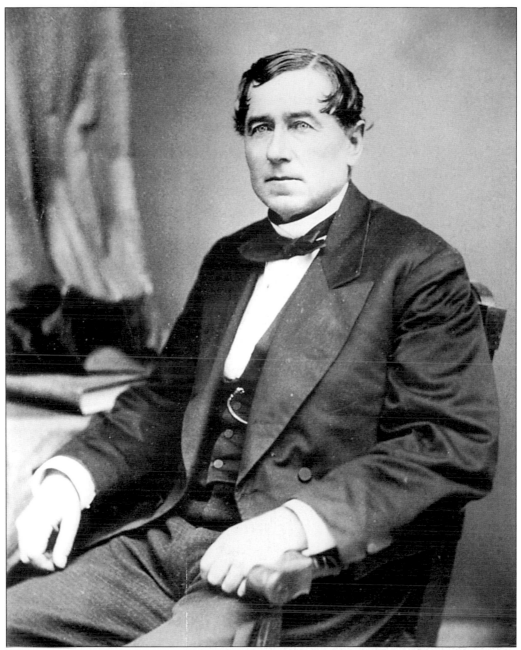

Alexander Blue was born in 1817 in Deerfield, New York. In 1832, he and his family moved to Livonia. He married his wife Catherine in 1842 and they had three children: Malcolm, Daniel, and Mary Catherine. Aside from tending to his farm, he held a number of offices in the community, including: township assessor (1841), justice of the peace (1846–1874), township supervisor (1864–1866), Elm School Board (1869), postmaster of Elm (1881), Wayne County drain commissioner (1865), and Wayne County Board of Auditors (1870s). He died in 1882.

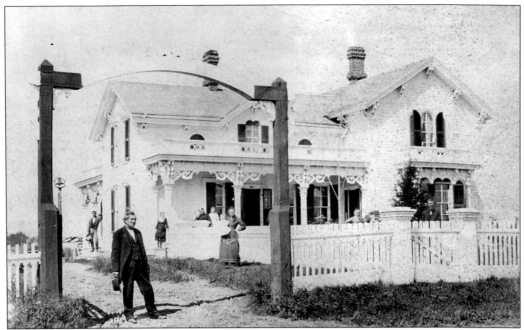

Alexander Blue's house was located on Middlebelt Road and was built in the mid-19th century. After falling into disrepair, the dilapidated home was moved to Greenmead Historical Park in 1987, where a painstaking restoration has returned it to its 1880 glory.

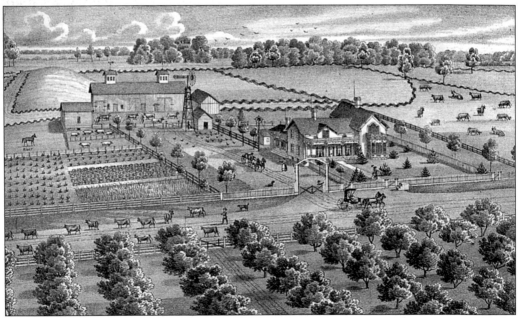

It's worth comparing the above photograph to this artistic rendering of the property from the *Illustrated Historical Atlas of Wayne County* of 1876. The house and farm are shown in extreme detail, right down to the pine tree directly in front of the house.

Alexander Blue's office was also referred to as a courthouse because he served as a justice of the peace from 1846 to 1874. Located on Middlebelt between Schoolcraft and Lyndon, the office was moved to Greenmead Historical Park in 1979.

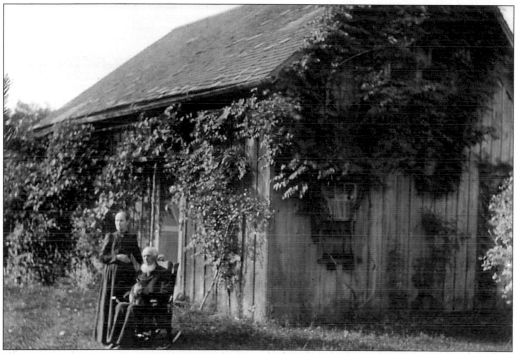

This is an 1895 image of Amos Pickett (1821–1907) with his wife, Caroline. Amos had been born in New York and Caroline was from Vermont. They were married in 1853 and had five children. Amos was a cooper with a relatively small 18-acre farm. Caroline died in 1916 at age 89. Both are buried in Newburgh Cemetery.

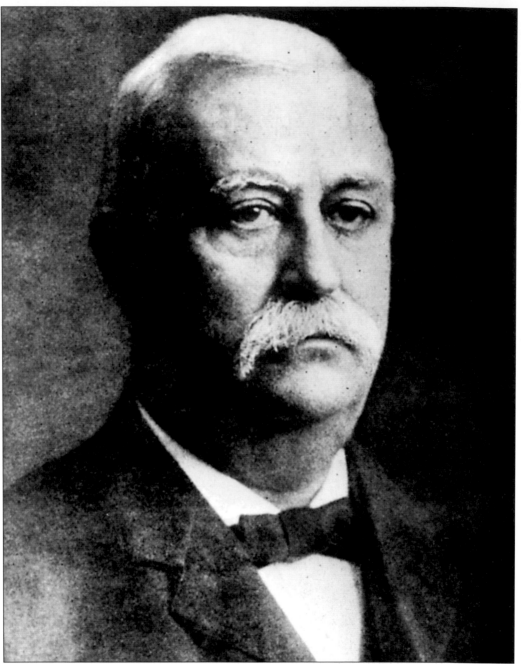

Alfred Noble, born on August 7, 1844, is one of the most distinguished citizens to have come from Livonia. He enlisted in C Company of the 24th Michigan Infantry on August 9, 1862, and was one of the few men in that company who escaped death or injury during the Battle of Gettysburg. After the war, he graduated from the University of Michigan in 1870 and went on to become one of the leading civil engineers of his age, working on the Panama Canal and the Pennsylvania Railroad Terminal in New York City, which necessitated extensive tunneling beneath the North and East Rivers, as well as the Borough of Manhattan. The Alfred Noble Public Library in Livonia is named in his honor.

John E. Ryder was 19 years old when he joined company C of the 24th Michigan Infantry. He was the son of George and Henrietta (Vinton) Ryder and attended the log cabin school that was located at Newburgh Road and Ann Arbor Trail with his older brother, Alfred. John wrote numerous letters home to his parents, commenting in one that, "They [the Confederates] said they did not want to fight, but had to, they told us. They thought if the privates could settle this war it would be done quick. We told them we did not want to unless they would lay down their arms. . . . They said we Michiganders was the grittiest boys they ever faced." John was killed on July 1, 1863, in the first day of fighting at Gettysburg.

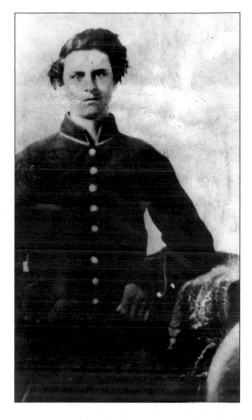

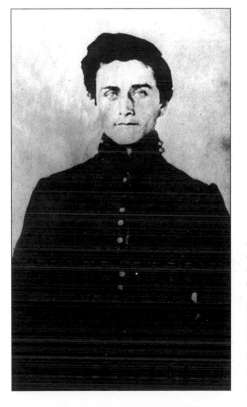

Alfred G. Ryder was enlisted in Company H of the 1st Michigan Cavalry (a unit that was commanded by 24-year-old General George Custer). Just days before the Battle of Gettysburg, Alfred Ryder had a chance to meet up with his brother, John, and they talked long into the night before going to their respective fates. Alfred was shot in the chest on July 3rd and died in a Gettysburg hospital on July 22nd. Both brothers were brought home by their father and are buried in Newburgh Cemetery.

Edgar Durfee was yet another Livonian who fought at the Battle of Gettysburg. He lost an arm when it was shattered by a minie ball (a cone-shaped lead slug). Following the war, Durfee became a probate judge in Detroit and kept that position for 50 years. He is also one of the men responsible for bringing Detroit its first professional baseball team in 1886. The Detroit Wolverines (a National League team) went on to win the World Series in 1887. Despite having only one arm, Durfee was an avid duck hunter and was also well-known for his spectacular rose garden.

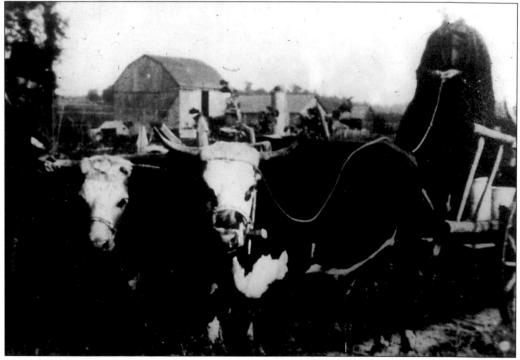

"Moving on up," as the expression goes, was a distinctly different experience in the 19th century as compared to today. When the McKinney family came to Livonia, part of their journey consisted of a four-day boat trip that took them through the Erie Canal. Once in Detroit, they continued to head west with all of their belongings on an oxcart, a fairly typical means of transportation for incoming settlers. When they were finally established at their new homestead, the oxen could then be used to plow the fields.

Elm School was built by the Wilson Brothers in 1869 and it was modeled on the "ideal" schoolhouse as defined by State Superintendent of Public Instruction John D. Pierce, the first person to hold this office. Located on Middlebelt Road, south of the railroad tracks, it subsequently became a two-room building in the early 1900s. This photo shows the school in 1962; it was demolished in 1973. (Courtesy of Nick Mladjan.)

While it was the Rouge River that brought settlers to the area, these railroad tracks running east and west through Livonia are what eventually brought companies like General Motors and Ford to the city. Opened on September 12, 1871, the line was originally known as the Detroit-Lansing-Lake Michigan Railroad, then was incorporated into the Pere Marquette line before becoming part of the Chesapeake & Ohio line.

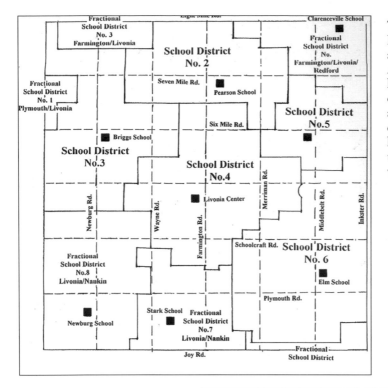

This map shows the Livonia School Districts as they appeared in 1873. As of 1870, Livonia only had 1,679 residents, so eight schools might seem a bit excessive, but these one-room schoolhouses had to be close enough so that the students could walk to school.

This map from 1876 shows what Wayne County looked like as the United States turned 100 years old. Still almost entirely rural, Livonia is only notable for its stations on the Detroit-Lansing-Lake Michigan Railroad. (Courtesy of the Wayne Historical Museum.)

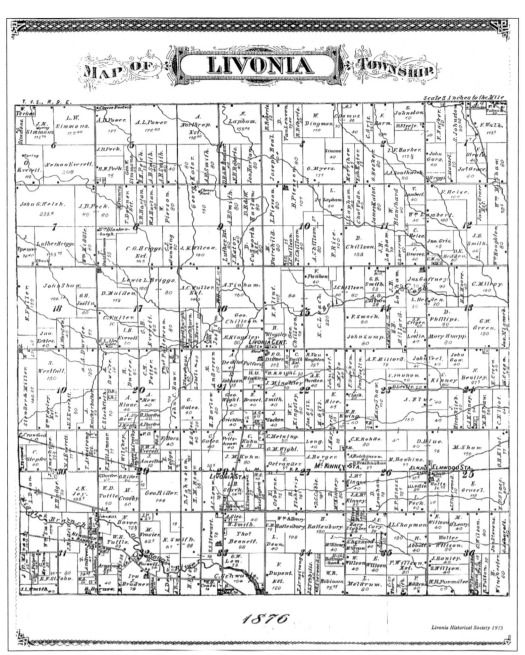

*1876*

Livonia Historical Society 1975

This 1876 map of Livonia Township is particularly useful to genealogists attempting to trace their ancestors, as it lists the names of the people who owned various tracts of land, as well as precisely how much acreage they owned. It also lists various landmarks such as springs and cheese factories, and notes the three Livonia stations utilized by the railroad (Livonia Station at Stark, McKinney Station at Merriman, and Elmwood Station at Middlebelt).

The Union Church located on Farmington Road just south of Five Mile Road was built in 1880 for about $800. It served non-denominational worshippers at Livonia Center. A Grange Hall which had been built in 1876 was subsequently moved and added to the rear of the building in the early 1900s, and after the Civil War the church was reputedly a gathering place for members of the Ku Klux Klan. The building still stands today and is used as a day care center.

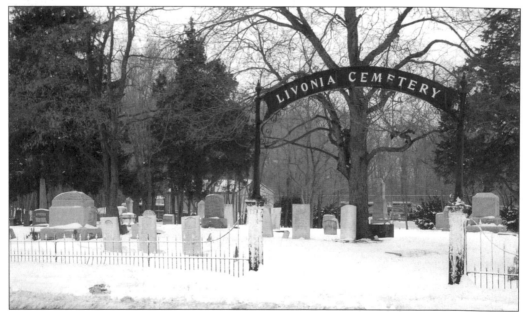

On September 25, 1836, the Union Society of Livonia paid Ephraim Butterfield $1 to use this land as a cemetery. Placid as it might seem today, the Livonia Cemetery was the subject of body-snatching raids in the late 19th century. Ambitious medical students would dig up freshly buried corpses and take them away for study. In many cases, friends and family members would line graves with bricks or watch over a new grave for a week or two to guard a loved one who might otherwise wind up on a dissection table.

This is George N. Bentley's graduation photo from 1894. Bentley attended Elm School from 1882 to 1891 and later taught there. The Bentley family settled in Livonia in 1843. George Bentley was involved with Livonia schools for over 35 years, and when Livonia's second high school opened in 1947, it was named in his honor.

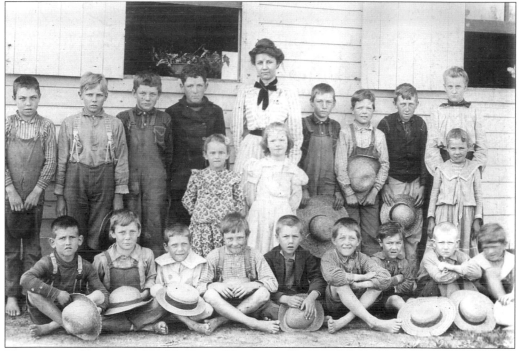

These are students attending Newburg School sometime in the 1890s. Built in 1861, it was a one-room schoolhouse on the corner of Newburg and Ann Arbor Roads. This frame building was used until 1922, when it was replaced by a multi-room brick building. While the brick school was demolished in 1974, this building was moved to Greenmead Historical Park in 1987 and it is used to give students a taste of what it was like to go to school in the 1910–1920 era.

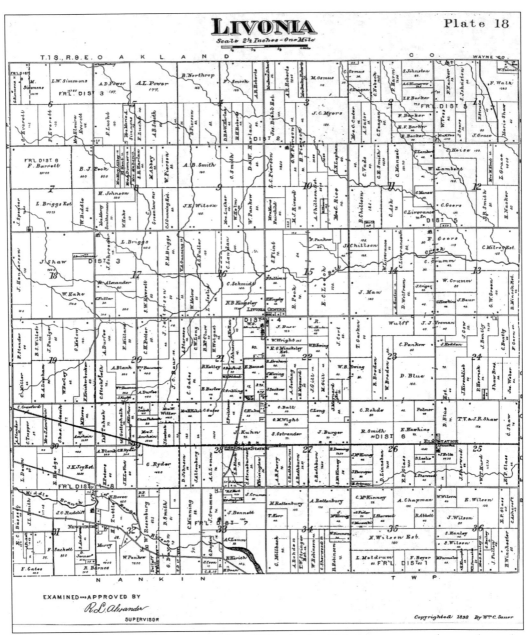

This map shows how Livonia appeared in 1893. As the 19th century wound to a close, the township was filled with farms, with some of the largest tracts of land being owned by pioneer families such as the Ryders, Shaws, Simmons, Briggs, Blues, and Wilsons.

# Three

# 1900s

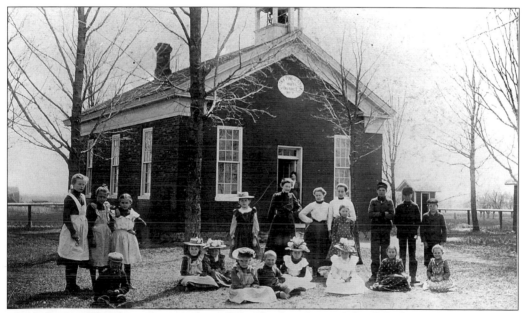

This is Briggs School as it appeared in 1902. The first Briggs School, built in 1831, was a one-room schoolhouse at the corner of Newburgh and Six Mile Roads. The school was rebuilt five times, this version dating from 1859. There was a water pump in the front yard, a red barn was used to store firewood, and there were two red outhouses in the backyard. It was used until 1945, when it became a storage building for school records and furnishings. Torn down in 1964, the shops of Newburgh Plaza now occupy the site.

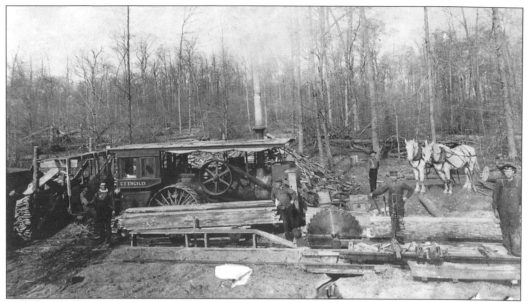

These men were all employees of the C.E. Kingsley Lumber Company, which was located in Perrinsville. While the company was headquartered just south of Joy Road on land now occupied by the Hawthorne Valley Golf Course, this portable sawmill would have been moved all over the area, on the premise that sometimes it is easier to bring the sawmill to the trees than to bring the trees to the sawmill.

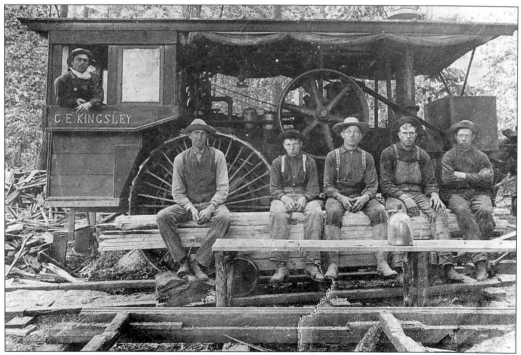

This closer photo of the portable sawmill was taken the same day as the above image. As was customary in the early days of photography, subjects were told to sit or stand completely still to allow time for the negative to be sufficiently exposed.

Frederick Dietrich arrived in Livonia c. 1900 and farmed 80 acres of land north of Seven Mile and west of Farmington Road. In 1903, he bought the former Quaker Meeting House to use as his home (it was in use as a residence from 1860 to 1961).

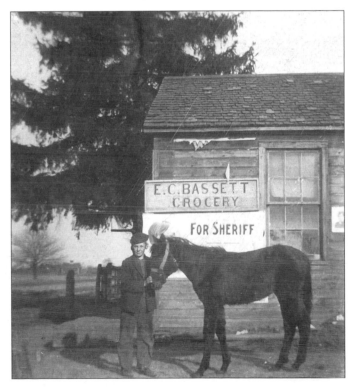

This 1901 photo shows E.C. Bassett's grocery store at Newburg. In addition to running his store, Bassett also served as a justice of the peace.

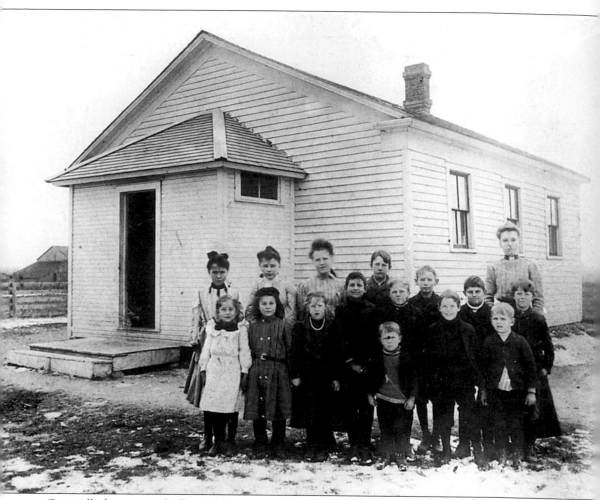

Originally known as Gaffney School, this is Wilcox School as it appeared in the early 1900s. Teacher Anna Thayer has shepherded her students outside on a cold day for a class photo. Located at Middlebelt and Six Mile Roads, a bell tower was subsequently added to the building.

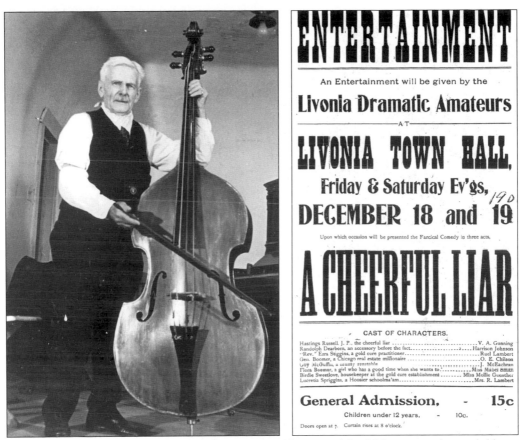

Culture may not have been abundant in Livonia at the turn of the 20th century, but it did have its place. Volney Gunning (1851–1945), who took the lead role in a 1903 production of *A Cheerful Liar*, was a cultural institution unto himself. Not only a farmer, he served as township treasurer and tax assessor in 1886, justice of the peace in 1893, and was master of the Livonia Grange. He was also an actor and a dance-caller, and kept a detailed diary about Livonia and its citizens from 1881 to 1938. As if that weren't enough, he was such a talented musician (playing the bass, fiddle, organ, and accordion) that Henry Ford himself would pick Gunning up so that he could perform at either the Botsford or Dearborn Inns.

This farm was located on Plymouth Road between Middlebelt and Merriman Roads and belonged to the Clement family. The site was subsequently the location of Shores Flowers, then Lum's Restaurant, then the Clock Restaurant, and then Archie's Restaurant.

This is an image of the Riddle Farm at Six Mile and Newburgh Roads. Mrs. Stringer is delivering some groceries from her store, which was on Five Mile Road near Farmington Road. Today, the site of the Riddle Farm is the Laurel Park Place shopping mall.

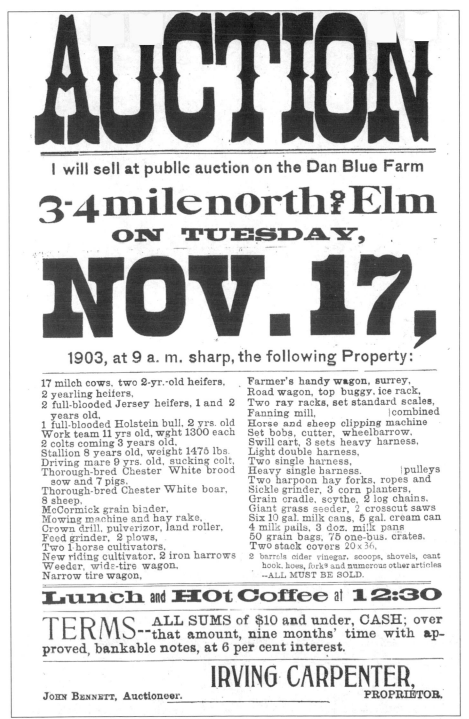

# AUCTION

I will sell at public auction on the Dan Blue Farm

# 3·4 mile north of Elm

## ON TUESDAY,

# NOV. 17,

1903, at 9 a. m. sharp, the following Property:

17 milch cows, two 2-yr.-old heifers,
2 yearling heifers,
2 full-blooded Jersey heifers, 1 and 2
   years old,
1 full-blooded Holstein bull, 2 yrs. old
Work team 11 yrs old, wght 1300 each
2 colts coming 3 years old,
Stallion 8 years old, weight 1475 lbs.
Driving mare 9 yrs. old, sucking colt,
Thorough-bred Chester White brood
   sow and 7 pigs,
Thorough-bred Chester White boar,
8 sheep,
McCormick grain binder,
Mowing machine and hay rake,
Crown drill, pulverizor, land roller,
Feed grinder, 2 plows,
Two 1-horse cultivators,
New riding cultivator, 2 iron harrows
Weeder, wide-tire wagon,
Narrow tire wagon,

Farmer's handy wagon, surrey,
Road wagon, top buggy, ice rack,
Two ray racks, set standard scales,
Fanning mill,                    }combined
Horse and sheep clipping machine
Set bobs, cutter, wheelbarrow,
Swill cart, 3 sets heavy harness,
Light double harness,
Two single harness,
Heavy single harness.        }pulleys
Two harpoon hay forks, ropes and
Sickle grinder, 3 corn planters,
Grain cradle, scythe, 2 log chains,
Giant grass seeder, 2 crosscut saws
Six 10 gal. milk cans, 5 gal. cream can
4 milk pails, 3 doz. milk pans
50 grain bags, 75 one-bus. crates,
Two stack covers 20 x 36,
2 barrels cider vinegar, scoops, shovels, cant
   hook, hoes, forks and numerous other articles
   --ALL MUST BE SOLD.

## Lunch and HOt Coffee at 12:30

# TERMS-- ALL SUMS of $10 and under, CASH; over that amount, nine months' time with approved, bankable notes, at 6 per cent interest.

# IRVING CARPENTER,

John Bennett, Auctioneer.

PROPRIETOR.

Auctions were a regular part of life at the turn of the century, usually when someone died or retired. This auction was held on the farm of Dan Blue, son of Alexander Blue.

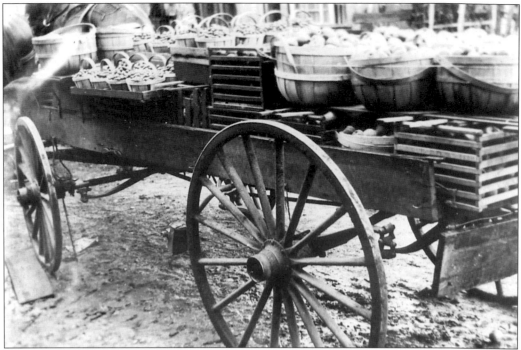

"Truck farming" was a popular way for Livonia farmers to get their produce to market. Wagons would be loaded up with the fruits and vegetables of family and neighbors and taken to the market in Detroit. Major crops from Livonia included apples and peaches.

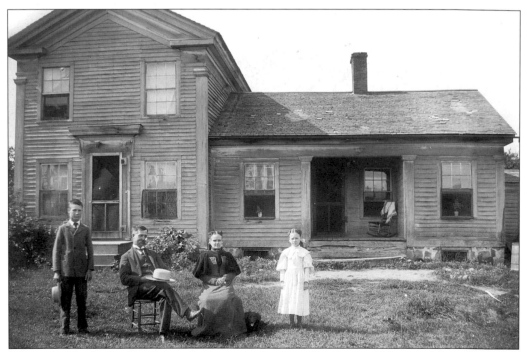

This is the Knickerbocker Farm, which was on Amrhein Road west of Newburgh Road. Posed in front of their Greek Revival style house are (from left to right) Fred, Frank, Emma, and Eva.

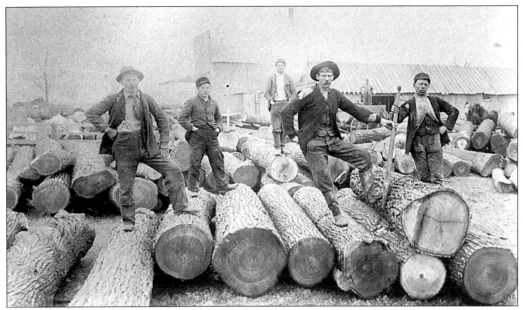

The Rohde Sawmill was located on Merriman Road, north of the railroad tracks and on the west side of the road. A sawmill had been on this piece of property for decades and it had passed through numerous owners before Guilford Rohde purchased it in 1886. He kept it in operation until about 1910 when he went out of business.

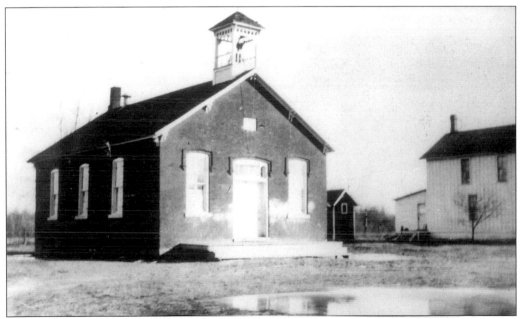

This image shows the Livonia Center School with the Union Church right next door. The structure visible behind the church is Grange Hall. The original log cabin school built on this site was called the Tamarack School (after the large number of tamarack trees in the area). The first Livonia Township meeting was held in Tamarack School in 1835, and the school was subsequently renamed Livonia Center School, District #4. It was built on John Joslin's farm and the log cabin was replaced by a frame building after the establishment of a local sawmill.

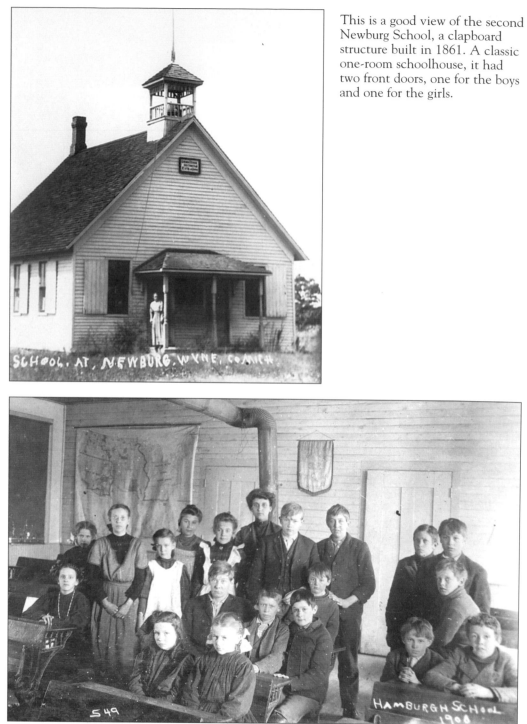

This is a good view of the second Newburg School, a clapboard structure built in 1861. A classic one-room schoolhouse, it had two front doors, one for the boys and one for the girls.

Don't be fooled by the "Hamburgh School" designation. This is the interior of Newburg school in 1908, an era in which students sat two to a desk. Modern-day students can still enjoy this cozy arrangement, as both the school and the desks are available at Greenmead Historical Park for field trips into a school of the past.

*Four*

# 1910s

This store and gas station owned by the Bentley Bros. was located on Middlebelt Road, north of Plymouth Road in the crossroad community known as Elm. It sold a wide variety of goods: Polarine Motor Oil and Greases, Holiday Goods, and Milwaukee Harvesting Machines and Twine. The Milwaukee Harvester Company was one of five companies consolidated into the International Harvesting Company in 1902, and the symbol of IHC is printed on the small advertising sign extending from the right side of the porch roof.

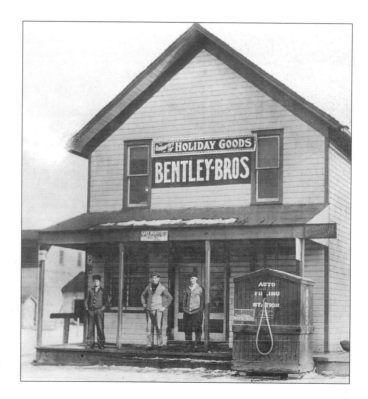

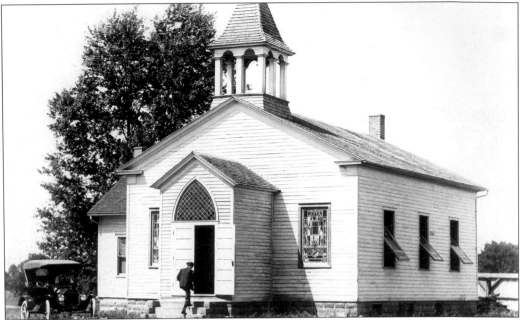

Built in 1848 to serve as a Presbyterian Meeting House, this building eventually became the home of the Methodist Episcopal Church, which had been founded by Marcus Swift in 1834. Initially located on Ann Arbor Trail across the road from Newburgh Cemetery, it was moved to the northeast corner of Ann Arbor Trail and Newburgh Road in 1915 (pictured here). Sunday school was held in the morning, with church services held in the mid-afternoon. The sheds behind the church were used for parking horses and carriages.

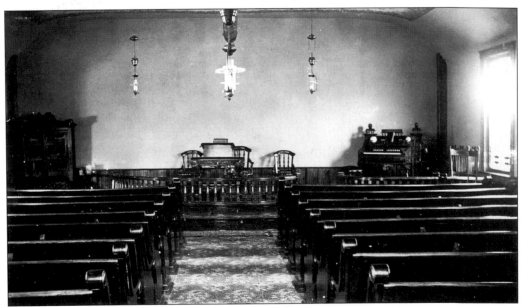

This is an interior view of the Methodist Episcopal Church from c. 1910. Not only were the walls of the church wallpapered, the ceiling was wallpapered, as well. In 1977, the church was moved to Greenmead Historical Park, where it has been restored to its 1910 appearance and is available for weddings and other functions.

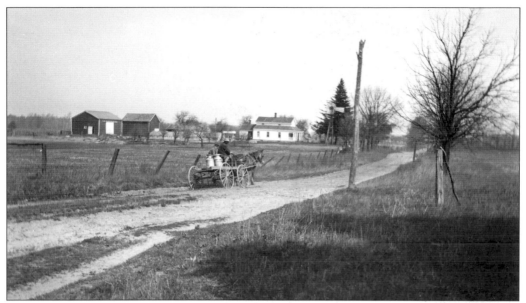

This 1913 photograph shows the Nathan B. Kingsley Farm and some milk cans heading north on Farmington Road. At the turn of the 20th century, Livonia was home to a number of cheese factories, so the Kingsleys always had a ready market for their milk.

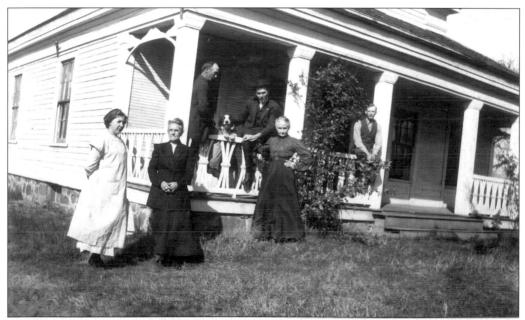

Second from the left is Emma Kingsley (1863–1927), surrounded by her family. The youngest daughter of Nathan B. Kingsley and Mary Grace Lambert, she stayed at the farm with her parents and married one of the farmhands—Joseph McEachran. They ran the farm together after Emma's parents died. When Joseph died in 1917, she sold the house and farm, which were on the west side of Farmington Road just north of Five Mile Road. The house was moved to Greenmead Historical Park in 1977.

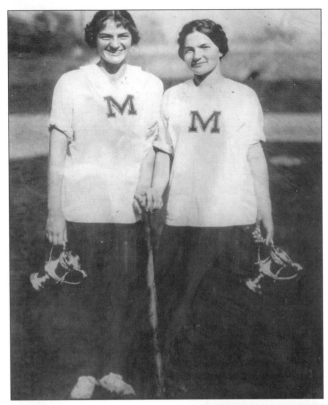

In 1915, Ida and Flossie McKinney were on the trophy-winning Michigan Bell Telephone Company's ladies' baseball team. The McKinney family had come to the United States from Ireland in 1839 and they built their home on Merriman Road just north of Plymouth Road in 1865. In fact, Merriman Road was once known as McKinney Road and the train station in the area was known as McKinney Station.

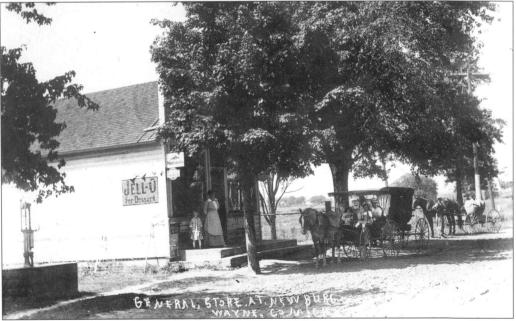

Proprietor A.J. Geer held the grand opening of his general store in December of 1912. Geer was also part of the school board for the Rough and Ready District, but met an untimely end when his car was hit by a train. The store is currently part of Greenmead Historical Park and has been restocked with period items.

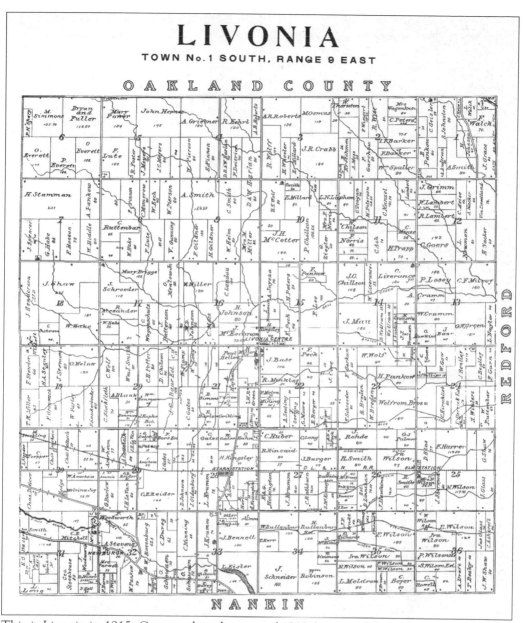

# LIVONIA
## TOWN No. 1 SOUTH, RANGE 9 EAST

This is Livonia in 1915. Compared to the map of 1893 (on page 38), it is apparent that not much has happened in 22 years. Some farms have changed hands, there are still two railroad stations, and the villages at Newburgh, Elm, and Livonia Center are all separate and distinct from one another. The next two decades would be a different story.

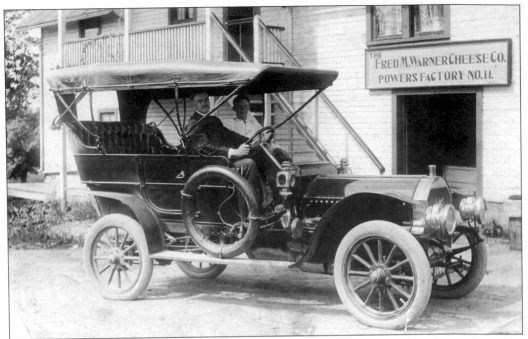

In the early 1900s, Fred Maltby Warner (1865–1923) began to buy up every cheese factory he could find. This one, at the corner of Newburgh and Eight Mile Roads is now the location of Whispering Willows Golf Course. In addition to being profoundly fond of cheese (or factories), Warner was also governor of Michigan from 1905 to 1911. He is shown here behind the wheel with his son, Harley, next to him.

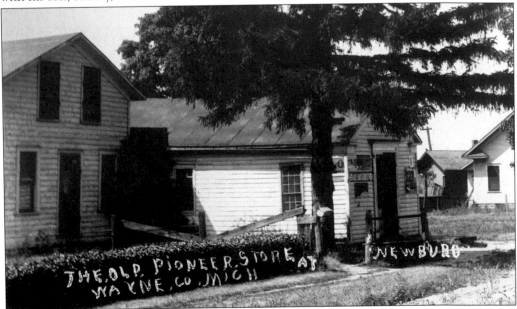

The Old Pioneer Store was located on the southeast corner of Newburgh Road and Ann Arbor Trail. In the background is the D.U.R. (Detroit United Railway) station, where passengers of the interurban train could be picked up or dropped off. Selling everything from Calf Meal to Jell-O, the store provided a wide variety of goods until it burned down *c.* 1910.

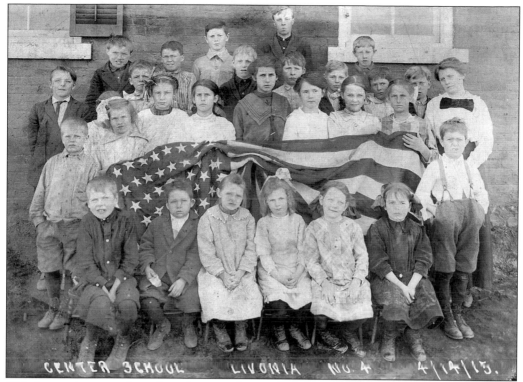

This image shows students from Livonia Center School in 1915. Between 1900 and 1920, it wasn't at all unusual for class pictures to include a large American flag. This brick version of the school had been built in 1872.

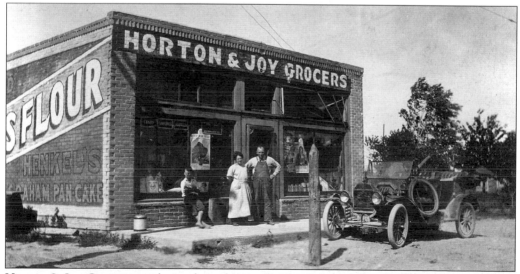

Horton & Joy Grocers was located on the south side of Ann Arbor Trail, west of Newburgh Road. This shows Jack Horton standing in front of the store. In addition to candy, groceries, and tobacco, the poster in the window indicates that War Savings Stamps are available, suggesting this photo is from around 1917 or so. The original building is still there, now boarded up and attached to a house.

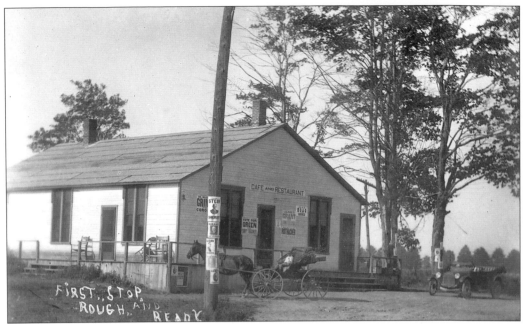

The area around Stark and Plymouth Roads was generally known as "Rough and Ready." It acquired this name when an old soldier by the name of David MacFarlane opened up a tavern here. Having served as a soldier under President Zachary Taylor, MacFarlane had a large mural of Taylor painted on the building, with a sword in each hand and his nickname "Old Rough and Ready" emblazoned beneath it. The tavern and then this entire area of the township came to be known by this name.

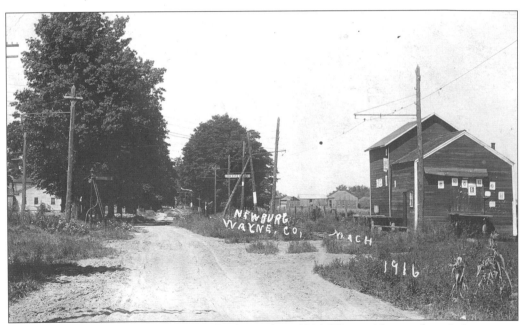

This is Ann Arbor Trail headed towards Plymouth in 1916. The visible sign doesn't designate a crossroad, but instead simply warns cars and pedestrians to "Look Out" for the interurban train that swept by on a regular basis. The building on the right was used as an icehouse.

*Five*

# 1920s

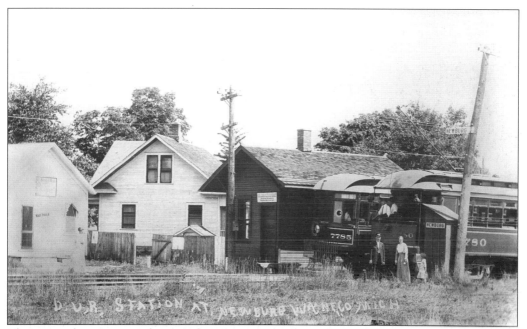

This interurban streetcar line ran between Northville and Wayne. Starting in 1899, its only scheduled stop in Livonia was at Newburg station, which was on the southwest corner of the intersection of Ann Arbor Trail and Newburg Road. While these cars would travel at 10 to 12 miles per hour in the city, they could approach 60 miles per hour in the country. The train derailed at least once in Livonia; Pennel H. Yorton was killed by a derailment on April 18, 1909. Gradually rendered obsolete by the automobile, this line was discontinued in the mid-1920s.

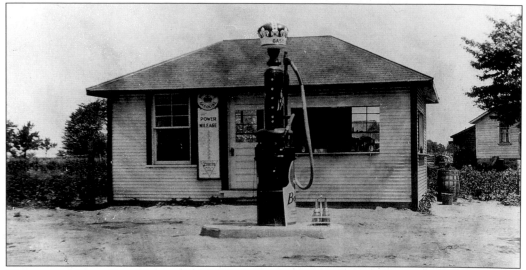

This gas station at Five Mile and Middlebelt Roads featured a single pump selling Red Crown Gasoline, one of the brand names utilized by the Standard Oil Company.

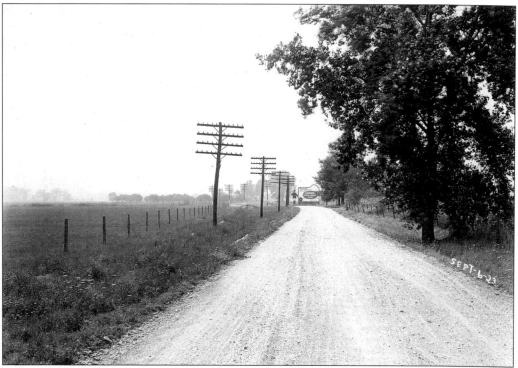

This is Plymouth Road at the Livonia-Redford Township line in 1923. The billboard strategically placed at a curve in the road reads, "Dangerous Curve Right Here!" and then goes on to add, "Hood White Arrow Cords—Risky to Pay Less, Needless to Pay More." The White Arrow Cord was a brand of tire sold by the Hood Rubber Co. of Watertown, Massachusetts, which was later bought out by the B.F. Goodrich Co.

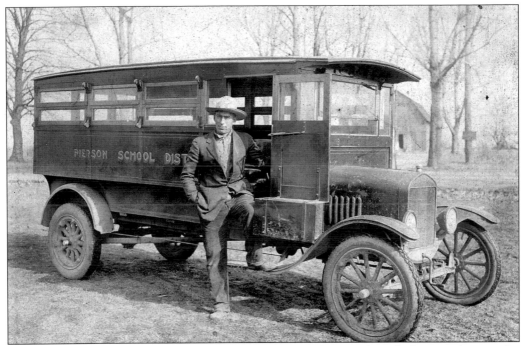

Pierson School on Seven Mile Road opened in 1921 with a grand total of 19 pupils in grades one through eight. This school bus would take the students to and from the school in high style. Pierson School would eventually close in 1969, although the City of Livonia continued to use the building for office space and it now houses private offices.

In 1923, the decision was made to pave Five Mile Road. This is perhaps the last photo taken of Five Mile as a dirt road. The rails on the left-hand side of the picture have just been laid down to bring in the cement for paving.

## LIVONIA TOWNSHIP
### TOWN 1 SOUTH, RANGE 9 EAST

This is Livonia in 1925. A number of farmers have sold their land to developers and various recreational venues are now available. The Northland (Northville) Country Club is open at Newburgh and Seven Mile Roads, and the Milroy Riding Academy at Six Mile and Inkster is also a new addition to the township.

This is Middlebelt Road looking north from Bonaparte (now Joy) in 1927. The roadside elm trees had been planted in the spring of 1925.

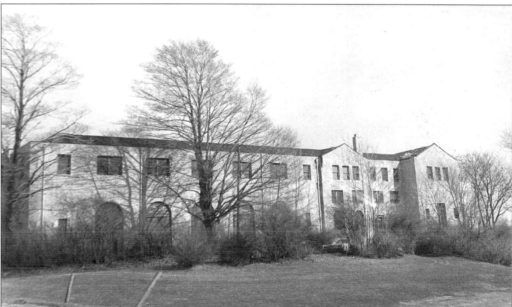

The Northville Golf Club was built in 1923. Once a showplace for music and dancing, with appearances by performers like Betty Hutton and Danny Thomas, the course and mission-style clubhouse had fallen into disrepair when this photo was taken in 1975. Despite its name, the course was located in Livonia on Newburgh between Six and Seven Mile Roads. During the 1920s, the clubhouse was reputedly a hangout for Detroit's Purple Gang, a largely Jewish Prohibition-era mob.

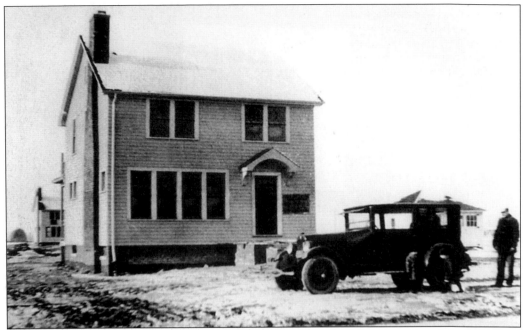

This is the Harsha home on Arden Avenue. It was the first home built in Rosedale Gardens, a subdivision begun in 1925 by the Shelden Land Company which was modeled after Rosedale Park on Detroit's northwest side.

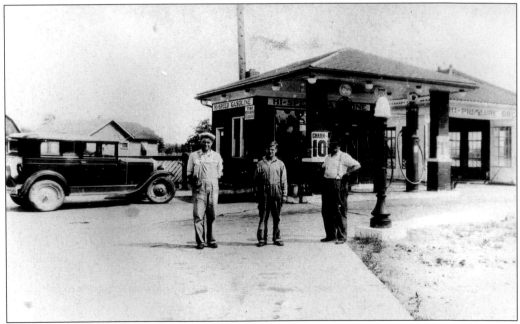

For its time, this was a fairly upscale gas station, offering not only gas at 10¢ a gallon, but also tire-repairing accessories and high-pressure greasing. Hi-Speed Gasoline had about 2,000 stations in Michigan and Ohio before being bought out by Pure Gasoline in 1951–1952. This station was located at the corner of Middlebelt and Seven Mile Roads.

This bridge was on Farmington Road, between Five and Six Mile Roads. Its purpose was to go over Bell Creek, which can be seen meandering through the foreground.

This is a view of the Johnson Farm, which was bought by the township. Although warned by the Johnson family that the land would periodically flood, the township converted the land into a park. Sure enough, it flooded, with the result that picnic tables wound up at Telegraph Road, courtesy of Bell Creek. The land just north of this site is now Burton Hollow subdivision.

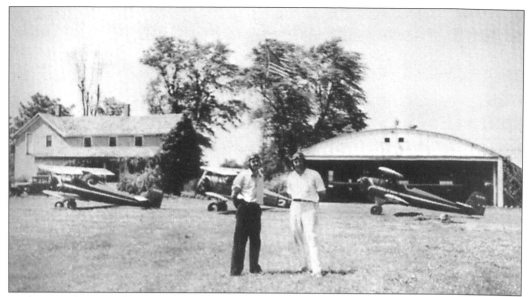

In the years between being a farm and Wonderland Mall, the land at Plymouth and Middlebelt served as National Airways Airport, which was established in 1916. Livonia also had a second airport at Ann Arbor Trail and Ann Arbor Road known as Triangle Field.

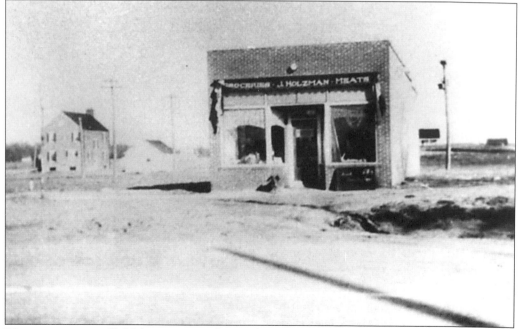

The grocery store of J. Holzman was at the northwest corner of Five Mile and Farmington Roads. Its clientele was largely from the Coventry Gardens subdivision, which began going up in 1925.

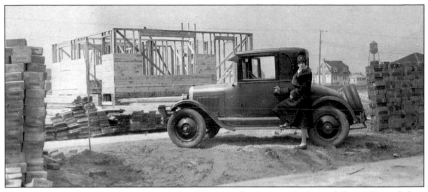

Construction has just begun on the Weinert home on Auburndale in Rosedale Gardens in 1927. The water tower in the distance was a necessity because there was no city water for Livonia yet. (Courtesy of Richard Weinert.)

The Weinert home is shown, with construction a little further along. The initial houses in Rosedale Gardens were wooden structures and the Shelden Land Company offered free Model T Roadsters to the first 25 families who bought homes. Subsequent buyers were offered a second lot for free. (Courtesy of Richard Weinert.)

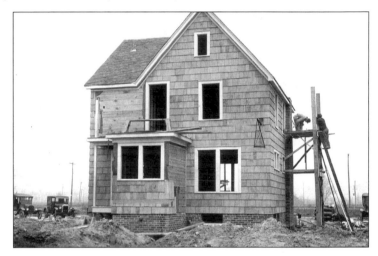

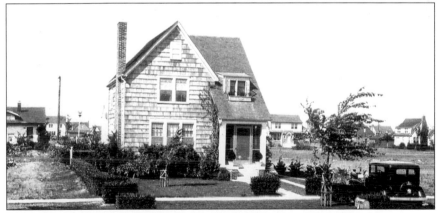

This is the completed Weinert home as it appeared in 1931. When the Depression hit, no new homes were built in Rosedale Gardens and some residents lost their homes. The developer used that period to brick over existing homes; brick was also used when building resumed later in the 1930s. (Courtesy of Richard Weinert.)

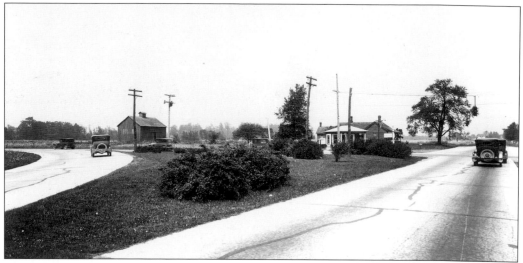

This image shows the intersection of Plymouth and Middlebelt Roads as it appeared on August 14, 1927. A series of similar photos was taken by the Wayne County Road Commission to record the paving plan that was connecting far-flung suburbs with Detroit. The gas station on the corner and the traffic light had both been installed within the last year.

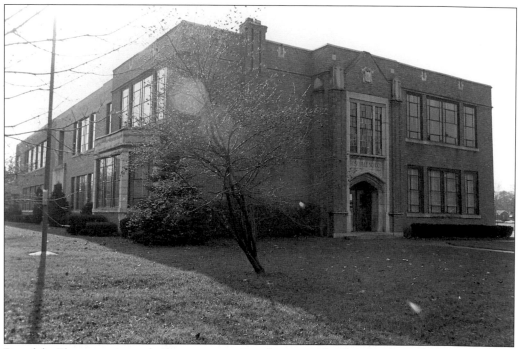

Rosedale Elementary was built as a two-story, four-room brick school in 1927 to serve the children living in the new subdivision of Rosedale Gardens. In 1940, four more rooms were added to the building, along with a kitchen and a teachers' lounge. The school was closed in 1979 and the building was demolished in 2000.

# Six

# 1930s

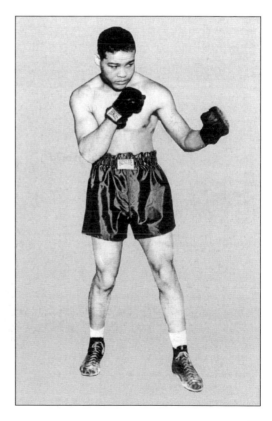

Joe Louis was heavyweight champion from 1937 to 1948. When in training for a fight, he preferred the relative isolation of the suburbs to the hustle and bustle of the city. Before buying Springhill Farm in Shelby Township in 1939, Louis would venture to the western suburbs for training sites. In Livonia, his preferred camp location was reputedly the Joshua Simmons Farm or the old A.D. Power Farm, both of which were on the south side of Eight Mile Road on opposite sides of Newburgh Road.

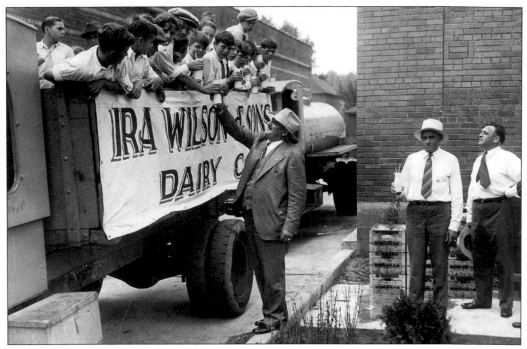

Born in Livonia in 1867, Ira Wilson was the grandson of Phineas Wilson and went on to become one of the most successful businessmen in Michigan in the 1930s. From his start in the dairy business on the Wilson Farm, he founded the Ira Wilson & Sons Dairy (his sons were Charles L. Wilson and Asa E. Wilson) in 1930 and soon had Wilson Dairy stores throughout southeastern Michigan. Here, he is running for Wayne County sheriff, a position that he held for two terms beginning in 1928. He died in Palm Beach, Florida, in 1944.

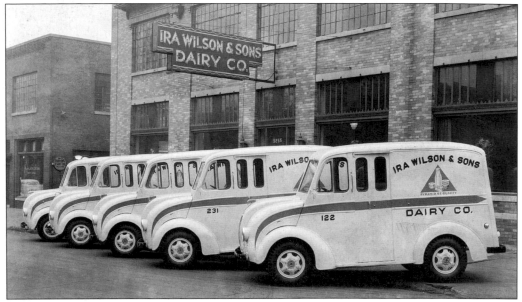

This photograph shows the Ira Wilson & Sons Dairy in Detroit and a small portion of their fleet of vehicles. The company symbol was a triangle representing a "Pyramid of Quality." Wilson Dairy continued its operations until it was sold to Melody Farms in 1981.

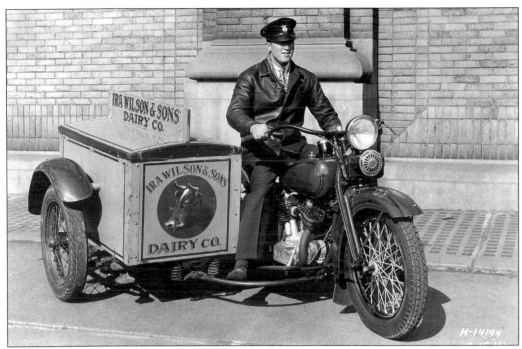

How serious was the Ira Wilson & Sons Dairy about not only getting their products out, but getting them out in style? This 1931 photo of a dapper deliveryman on a Harley-Davidson motorcycle should answer that question.

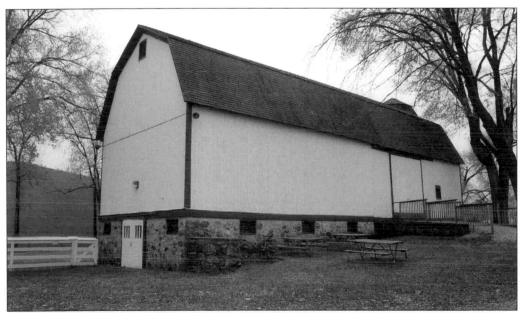

This is what remains of Ira Wilson's legacy—the Wilson Barn at Middlebelt and West Chicago Roads. The original Wilson Barn was built in 1888. When the first barn burned down in 1918, it was rebuilt the next year on the same foundation. In 1945, the ground level stalls were remodeled to house Arabian horses. Now considered a local, state, and national historic site, it hosts a farmers' market during the summer months and other events throughout the year.

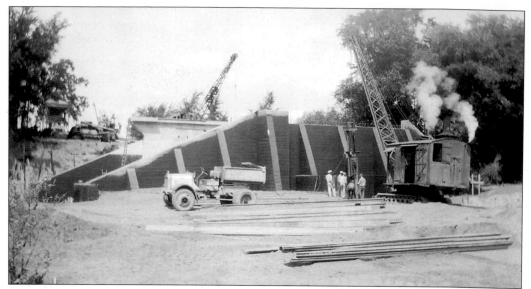

Newburgh Dam was built in 1933 as a cooperative project between Wayne County and Henry Ford. In 1935, the Ford plant at Newburgh Dam opened, manufacturing 95% of the drill bits needed by the Ford Motor Company. During World War II, the plant produced parts for airplane engines before being shut down in 1947 and deeded to the Wayne County Road Commission in 1948.

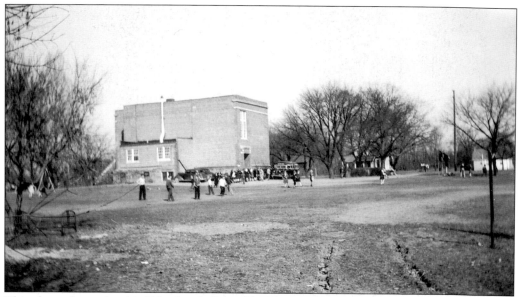

This photo shows the third Newburgh School building and its playground from the back. On the left hand side of the building was the fire escape tube. Students were either thrilled or petrified at the thought of sliding down from the second story in case of a fire. The school bus at the side of the building was painted in the patriotic colors of red, white, and blue.

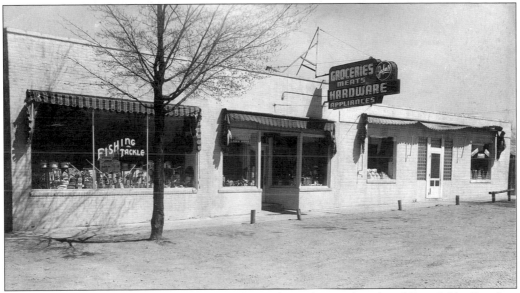

Jahn's Hardware and Grocery Store was located on the north side of Five Mile Road at Farmington. It opened in 1910 with the motto, "You'll find everything at Jahn's." In addition to hardware and groceries, goods included fishing tackle and various appliances. In fact, if you look closely in the shop window, there is a tricycle for sale as well.

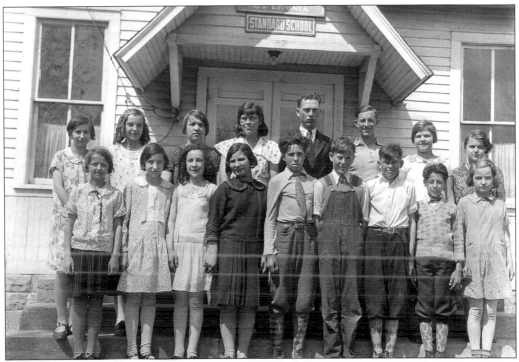

Stark was one of only two Livonia schools to be given the designation "Standard School" (the other being Briggs). This meant that the teacher had undergone good training and that the curriculum was of a high level. A one-room schoolhouse was built at Stark (which was also known as "Rough and Ready") in the 1890s and a second room was added in 1926.

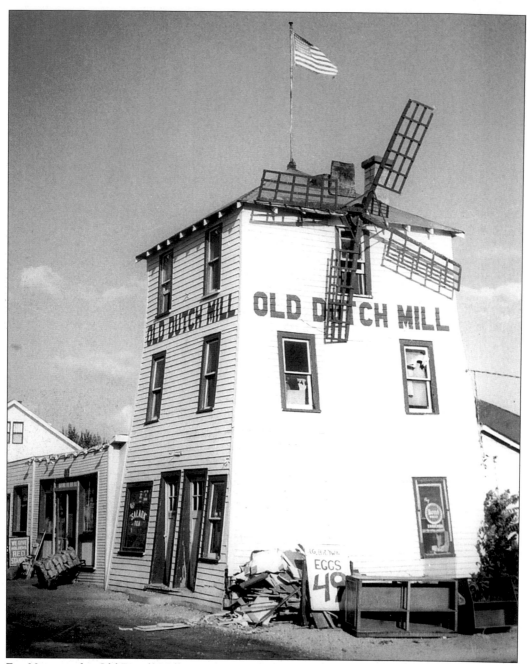

For 33 years, the Old Dutch Mill was a Livonia landmark. Opened by Clyde and George Bentley in 1924, it was located on the south side of Five Mile Road west of Inkster Road. Known as "The Turkey King of Michigan," Clyde Bentley held regular poultry auctions that were called "Feather Raffles." The mill was known to sell over 20,000 eggs on Sunday afternoons, and also hosted state horseshoe tournaments before the Bentleys sold it in 1947.

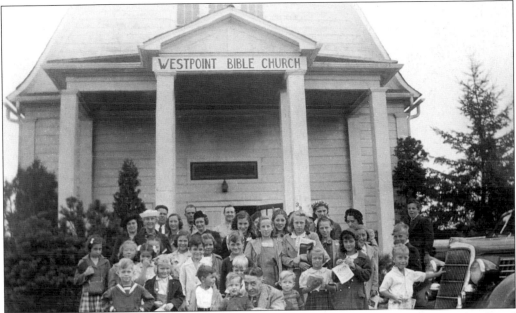

The Westpoint Bible Church on Seven Mile Road started out as the barn of Richard and Charlotte Wolfe. While the barn had originally been located on what is now a side street (Woodring), it was moved by a team of horses to its new location, where it was eventually transformed into this church.

What had once been the fields of the Kingsley Farm was transformed into the subdivision of Coventry Gardens beginning in 1925. In contrast to Rosedale Gardens, where the Shelden Land Company built the homes, in Coventry Gardens families bought the lots and then hired their own builders.

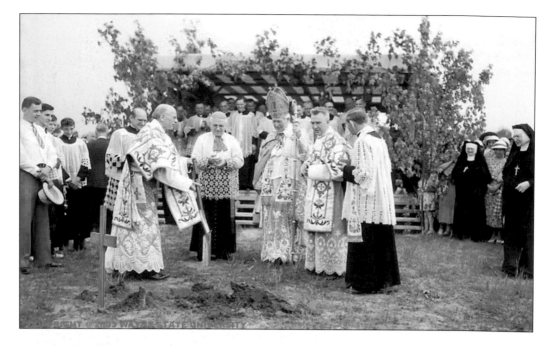

On Newburgh Road just north of Schoolcraft, this group of nattily-attired gentlemen (above) broke ground in 1935 for Villa St. Felix, the Mother House of the Felician Sisters. Soon enough, what began as little more than a few clods of upturned earth became the newly completed Villa St. Felix (below), which is styled after the early Christian Lombard architecture of Northern Italy. Presentation College (now called Madonna University) was opened in 1937 by the Felician Sisters and Ladywood High School would be established in 1950. (Both images courtesy of Walter P. Reuther Library, Wayne State University.)

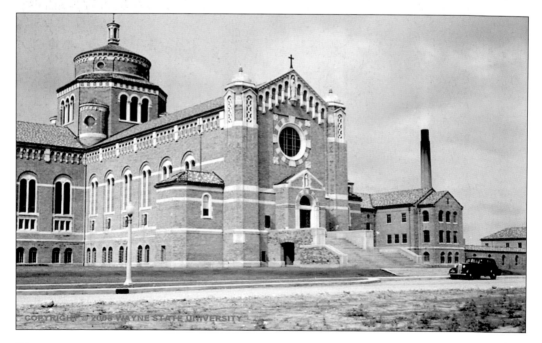

Livonia farmers get ready to drive their melons to the farmers' market in Detroit in 1938.

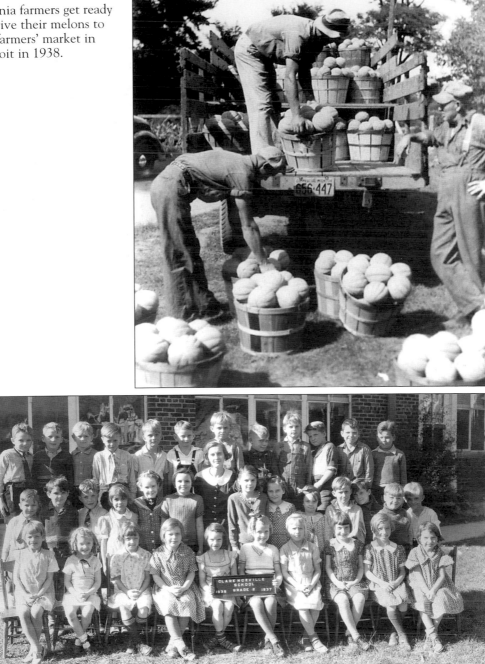

Some of these Clarenceville second graders seem happy to be outside, while others are less enthused. The Clarenceville School District was formed as Fractional School District No. 5 in 1837 (fractional meaning it served students from more than one township) and remains a separate entity from Livonia Public Schools to this day. The village of Clarenceville was the last stagecoach stop on the plank road running from Lansing to Detroit and it was named for Thomas Clarency, who owned what became the Botsford Inn. The first high school built in Livonia was Clarenceville High School in 1941.

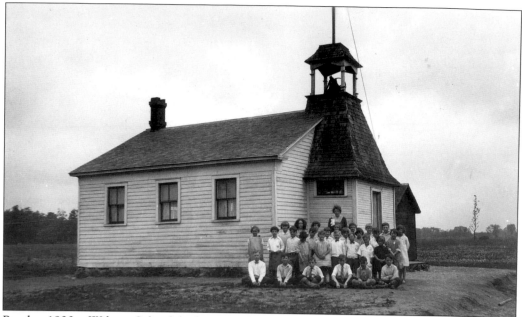

By the 1930s, Wilcox School had acquired its bell tower, but still served as a one-room schoolhouse until a second room was added in 1935.

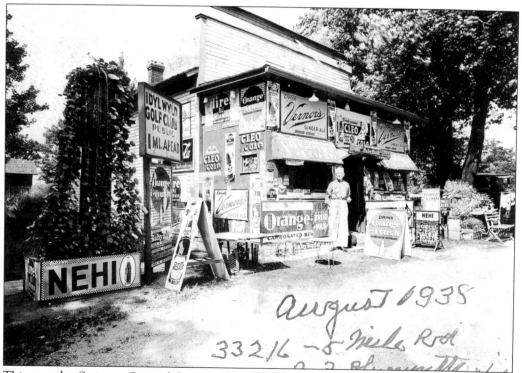

This was the Stringer General Store on Five Mile Road. What's remarkable about this 1938 picture is that out of all the beverages and candy bars advertised, only one, Cleo Cola, is no longer in existence. Even Idyl Wyld is still open to the public for a round of golf.

# Seven

# 1940s

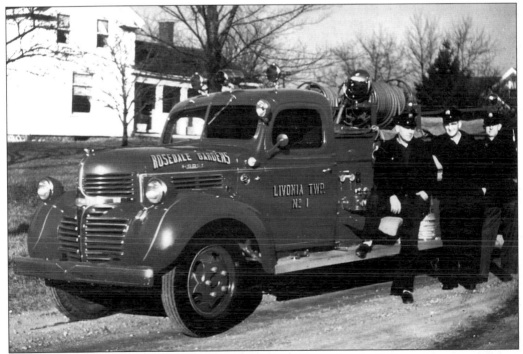

Livonia Township's first fire truck was purchased on November 1, 1941, and was housed in a gas station at Plymouth and Merriman Roads. A 500-gallon pumper, it was acquired largely at the behest of citizens of Rosedale Gardens. The pumper answered its first call on December 7, 1941, coincidentally the same day that Pearl Harbor was attacked by the Japanese.

This photo from August of 1941 shows a family having a picnic on the median of Schoolcraft Road, a little west of Farmington Road. In the 1970s, the I-96 expressway would replace the grass and trees and picnic tables.

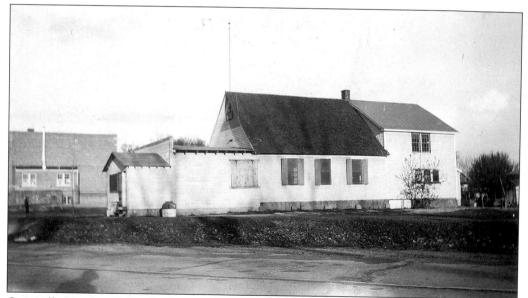

Originally Newburg School, this structure subsequently underwent a number of incarnations, being used as an antique shop and also as an apartment building. In the 1940s it was transformed into Kidston's Dance Hall. Today, it has been restored as Newburg School at Greenmead Historical Park.

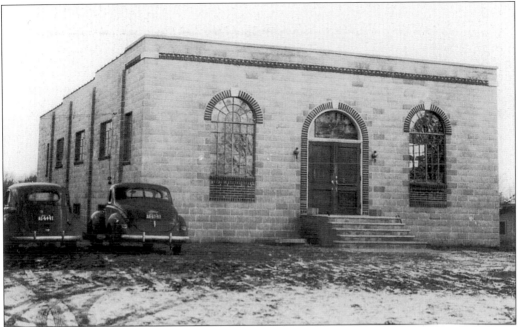

The Newburg Methodist Social Hall fulfilled any number of functions. Talks were given here, dances were held here, and it served as a meeting place for a variety of groups.

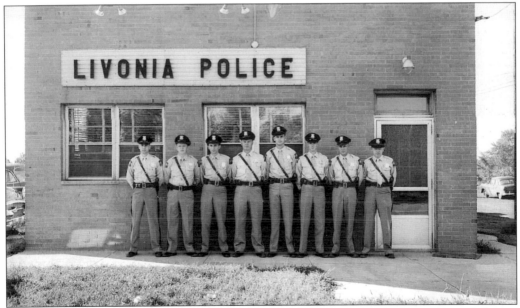

Livonia's finest stand in front of their relatively humble department building. A much bigger and entirely modern police station would be built in 1962.

If Livonians happened to glance into the sky on March 25, 1945, they might have seen a Japanese balloon bomb much like this floating overhead. The Japanese launched approximately 9,300 of these bombs (also known as Fugos) and the U.S. government kept their existence a secret until one of them killed six picnickers in Oregon on May 5, 1945. While newspaper reports subsequently declared that a Fugo had exploded in Livonia, the bomb actually floated slightly north, detonating in a Farmington family's backyard garden.

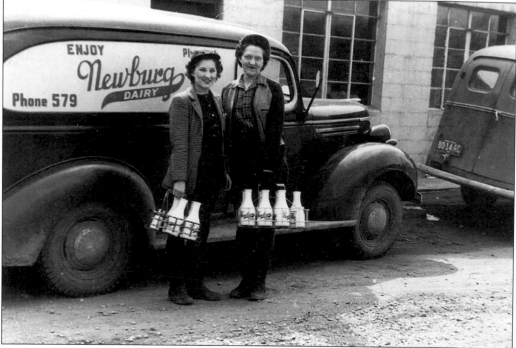

Cousins Molly and Milly Zielasko made their milk delivery rounds throughout Livonia during World War II. Almost all of the houses built in Livonia during the boom of the 1950s had milk chutes incorporated into their design, a quaint feature that has now fallen into disuse.

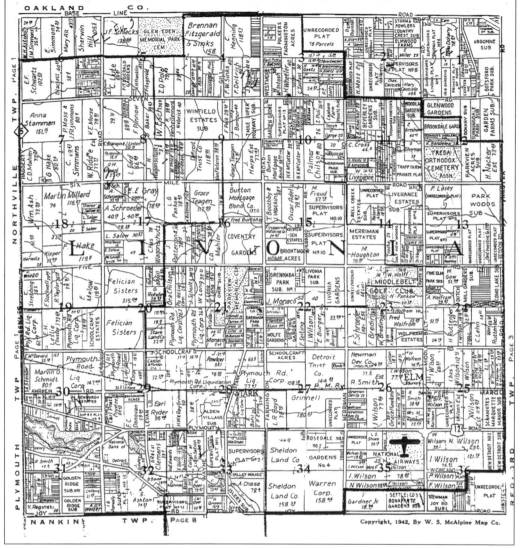

# LIVONIA TOWNSHIP
### TOWN 1 SOUTH, RANGE 9 EAST
*Complements of* BURTON ABSTRACT & TITLE CO., *Detroit, Michigan*

This 1942 map shows Livonia as the farms gave way to subdivisions. Farms are still listed with their acreage, but there is also the National Airways Airport at Plymouth and Middlebelt Roads and the Middlebelt Golf Club just two miles north. Henry Ford had bought up land around Newburg Lake and the Felician Sisters had just opened their Mother House. Eight years later, the township would become a city, and the full rush to becoming a suburban ideal would be on.

81

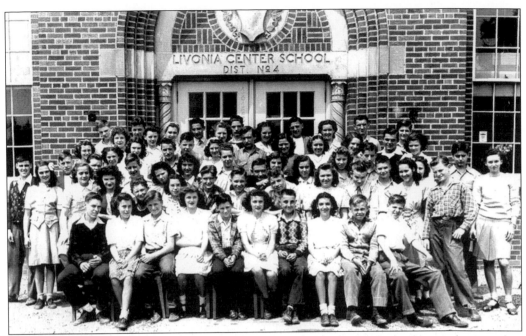

This is the Livonia Center School class that would go on to become the first graduating class of Bentley High School in 1950. This four-room, two-story brick structure was built in 1928. In 1944 it was put into service as a junior high school, but it became an elementary school once more in 1950.

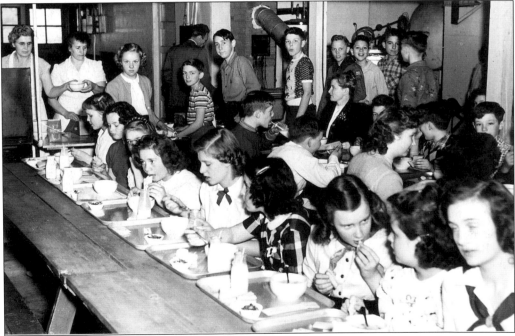

Livonia Center School's seventh graders pour into the lunchroom in 1949. In the back of the room with his back turned is Dominic Paris, the schoolteacher who wrote the first substantial history of Livonia, *Footpaths to Freeways*, in 1975.

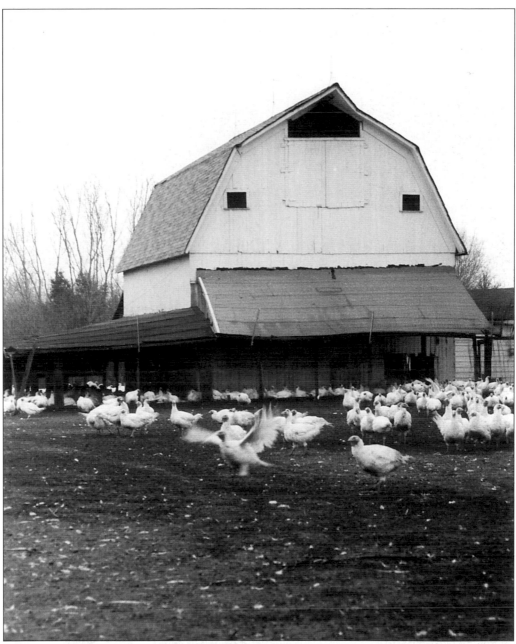

The Roperti Turkey Farm was opened by Thomas and Mary Roperti on Five Mile Road in 1948. Still in business today, it is one of the few vestiges of Livonia's rural and farming past.

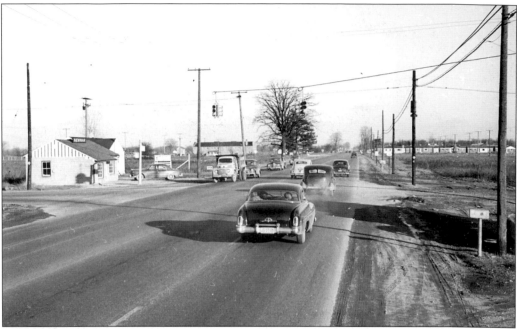

This is Plymouth Road looking east at Farmington Road. To the south, Farmington is still a dirt road. On the left is a model home of the Newman Construction Company.

Yes, there were actually postcards made for Riverside Roller Skating Arena. The back of the card advertises, "One of Michigan's finest roller rinks, located 7 miles from Detroit City limits on U.S. 12. A half acre to play and two acres to park." The first version of the rink opened in 1940 but was blown down during a windstorm. The current version is actually the third Riverside Arena.

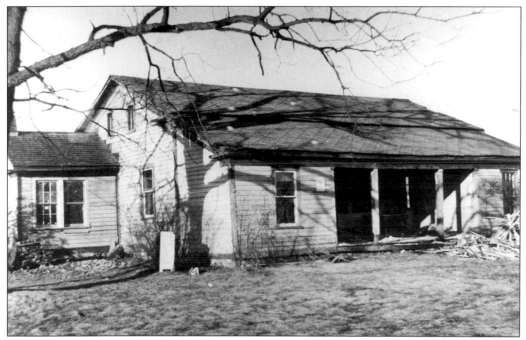

Even as more and more new buildings popped up, Livonia's more historic structures were often the victims of neglect. Quaker Acres was originally built in 1846 and this is what it looked like 100 years later. It would take a lot of time, effort, and money, but eventually the building would be restored to its original condition.

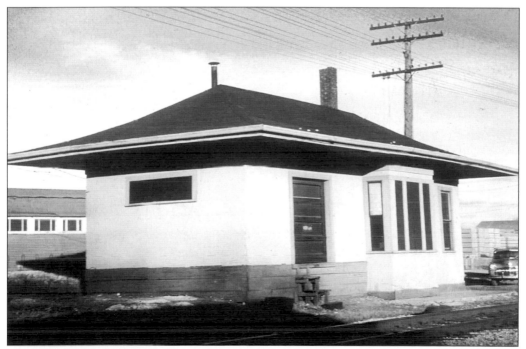

The old railroad depot at Stark was not as fortunate as Quaker Acres. Built in the 1870s, it is shown here when it had already been in disuse for years. It was torn down in the 1950s.

Although few alumni would recognize it, this is what Bentley High School looked like soon after it opened in 1947. It was named for George N. Bentley, who attended school in Livonia, taught school in Livonia, and then served on the Livonia Board of Education. In 1950, Bentley graduated its first class.

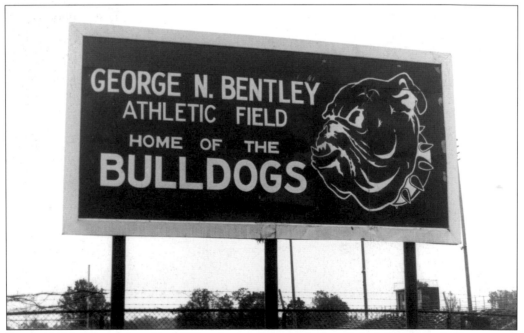

Bentley High School closed in 1985 and was subsequently demolished. The Livonia Community Recreation Center now occupies the site. Although the high school may be gone, George N. Bentley field is still in use. And just where is the famous bronze bulldog that once graced the halls of Bentley High? Its location is a closely-guarded secret known only to a select few.

# *Eight*

# 1950s

Livonia's Charter Commission had the responsibility of writing the charter that would define the kind of city Livonia would become. By a vote of 2,970 to 1,490, Livonians approved the charter on May 23, 1950 and Livonia ceased being a township and officially became a city. Seated from left to right are Wilson W. "Eddie" Edgar, William W. Brashear, Carl J. Wagenschutz, Harry S. Wolfe, Daniel McKinney, and Raymond E. Grimm. Standing from left to right are Fred Weinert, Rudolph R. Kleinert, and Leo Nye.

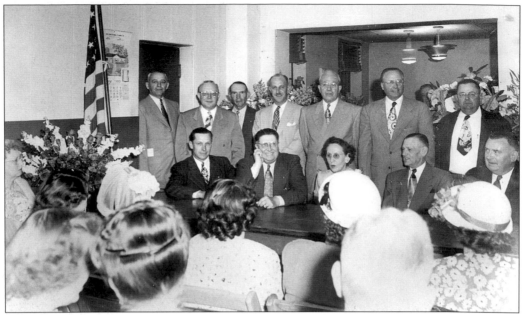

Here are the first city officials who were elected on May 23, 1950. Seated from left to right are Carl J. Wagenschutz (treasurer), Jesse Ziegler (mayor), Nettie Carey (councilwoman), John W. Whitehead (councilman), and Leo Nye (justice of the peace). Standing from left to right are Harry S. Wolfe (council president), Wilson W. "Eddie" Edgar (councilman), Raymond E. Grimm (councilman), Harvey Jahn (councilman), William Taylor (councilman), Ray Owens (constable), and John Miller (constable).

In the same month that Livonia became a city, Elm School put on its annual May Festival. Pictured here are the second, third, and fourth grade students. On the right-hand side of the picture is a maypole, around which the children would twirl as part of the festival.

Jesse Ziegler (1894–1974) was Livonia's first mayor, holding the office from 1950–1954. Prior to that, he was township supervisor for 28 years and he also served as Livonia's postmaster. His father, Otto, owned a cheese factory that was located on Six Mile Road between Middlebelt and Merriman Roads. When he passed away at age 80, he had spent every one of those years as a Livonian.

Elbert M. Hartom was Livonia's mayor from 1954–1956. A chicken farmer and ex-Army officer, Hartom was a controversial figure remembered for his loyalty investigations of city employees and having hooded witnesses testifying in secret. His reign as mayor was brief, and Hartom and his wife eventually retired to Costa Rica.

William W. Brashear was Livonia's mayor from 1956–1962. Prior to that, he had been appointed as Livonia's township attorney in 1949 and was a member of the Charter Commission; in fact, he was the man largely responsible for writing the charter. He served as an officer in the U.S. Navy during World War II and was also a special agent in the FBI during the war. Brashear was very pro-growth and it was during his administration that Wonderland Mall opened.

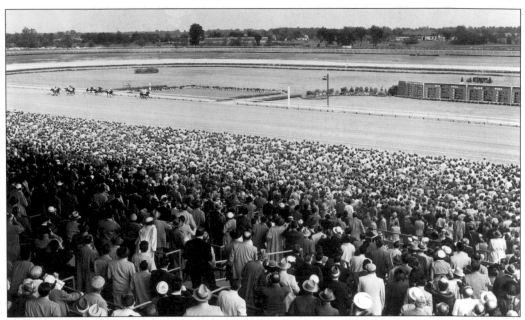

In large part, Livonia owes its existence as a city to the arrival of the Detroit Race Course, which opened on May 25, 1950. The mile-long track was built by the Michigan Racing Association at a cost of $5 million, but Livonia would only be able to take its share of the revenues if it became a city, which it did two days before the track opened. The result was that Livonia was able to keep its property taxes relatively low, enticing both businesses and homeowners to the community.

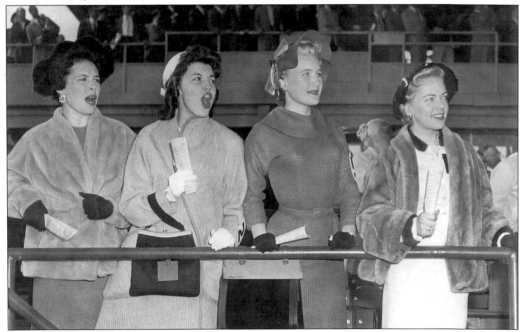

Programs gripped tightly, these fashionable women root on their favorites. Celebrities like Gordie Howe and Willie Shoemaker could also be spotted at DRC, which was the place to be in the Detroit metropolitan area during the 1950s.

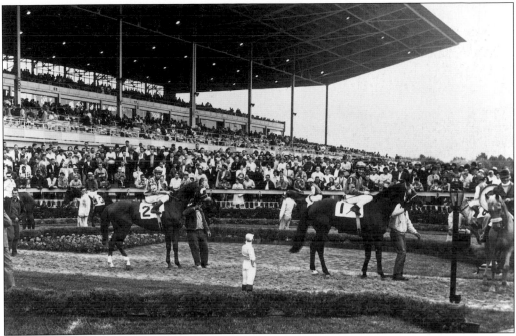

The annual Post Parade that opened the racing season was considered one of the sure signs that spring had arrived. While many citizens had been concerned about bringing legalized gambling to the area, DRC maintained good community relations by allowing children and their parents in for free on selected mornings to be taken around the track and watch the horses train.

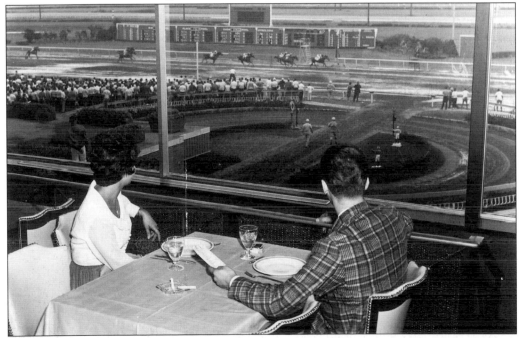

For years, DRC was considered the mecca of racing in the Midwest and it offered this 800-seat dining room to its patrons. Purchased by Ladbroke in 1985, the racetrack gradually went into decline as the popularity of horseracing diminished, and it was demolished in 1999.

The grandparents of Carl J. Wagenschutz immigrated to Livonia from Germany in the 1880s and the family eventually owned a 130-acre farm just west of Idyl Wyld Golf Course. Wagenschutz served as township treasurer from 1944 to 1950 and then city treasurer from 1950 to 1979. He was also a member of the Livonia Charter Commission.

Marie Clark was Livonia's first city clerk, holding that office from 1950 until 1964. She and her husband had moved from Algonac, Michigan, to Livonia in 1942. They ran a grocery store and then a gift shop on Plymouth Road.

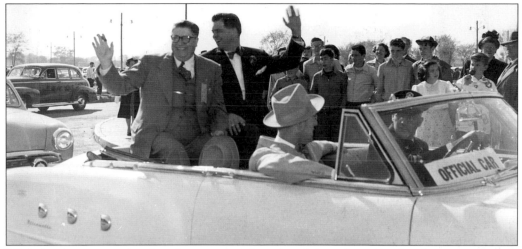

With his hat in one hand and a cigar in the other, Mayor Jesse Ziegler shares a ride with Michigan Governor Gerhard Mennen "Soapy" Williams, who came to Livonia for the seventh anniversary of Livonia's Rotary Club in 1952. Mayor Ziegler was a charter member of the Livonia Rotaries.

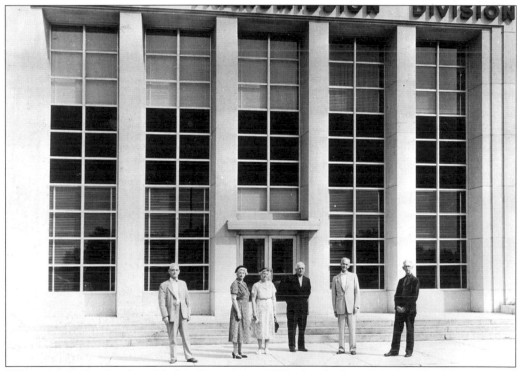

When the Ryder family settled in Livonia in 1827, the deed to their land had been signed by President John Quincy Adams. It wasn't until 1950 that the family sold their farm to the Ford Motor Company, who proceeded to open this Ford Plant in 1952. While it originally manufactured Patton 48 Medium Tanks, in 1954 it was converted into an automatic transmission plant with some 1.5 million square feet of manufacturing and assembly space. It must have felt a little surreal to the Ryders to pose in front of the plant, because only a few years earlier they had been plowing and tilling the very spot where they stood.

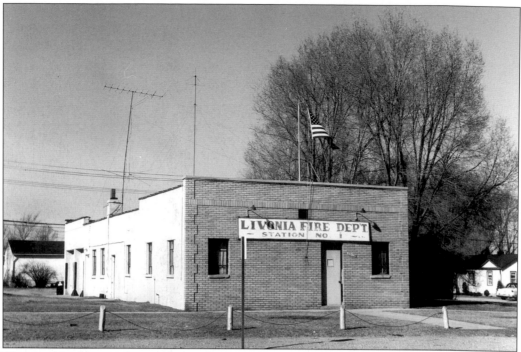

This small building on Five Mile Road just east of Farmington Road served the city in a number of capacities. It was used as the Township Hall, then the first City Hall. It was then turned into a fire station before being used by the Parks Department as a place to store lawn mowers and other tools. (Courtesy of Nick Mladjan.)

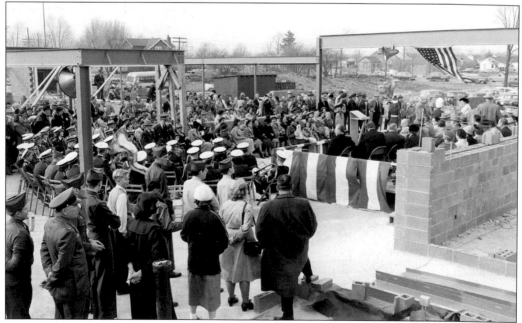

On November 2, 1952, a large crowd gathered for the cornerstone laying ceremony for Livonia's new City Hall. Providing musical accompaniment for the grand occasion was Bentley High School's band.

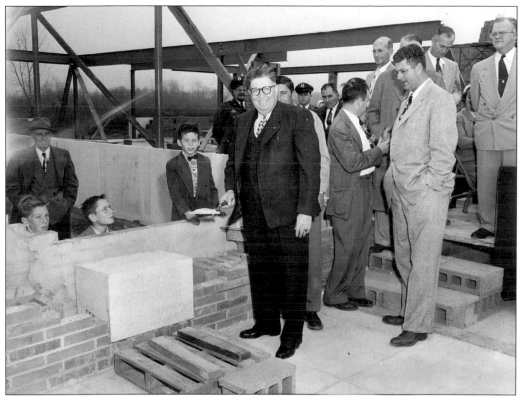

The cornerstone for the new City Hall has just been set in place by Mayor Jesse Ziegler.

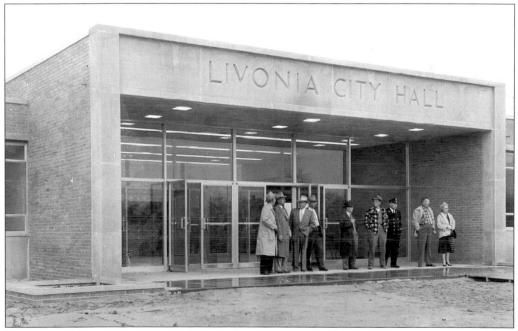

The newly finished City Hall was dedicated on September 13, 1953. The total cost of the project was $285,000, paid for in cash thanks to the revenue generated by the Detroit Race Course.

The Bank of Livonia on Five Mile Road east of Farmington was one of the first banks in the city, opening for business in 1952. In the 1960s, opening a new account here meant that you were eligible to receive one complimentary set of stainless steel cutlery.

This image looks north on Middlebelt Road at Plymouth Road in 1953. On the corner is the Mark Leach auto dealership, which was an authorized dealer of Lincoln and Mercury vehicles, and also sold used cars. The increase in traffic caused by the auto plants and the Detroit Race Course necessitated modernized traffic signals and new railroad crossing lights and barriers.

This aerial view shows Livonia's Civic Center as well as Five Mile and Farmington Roads. Lining the sidewalks to City Hall are Almey Crab trees; it is a little-known fact that the Almey Crab is Livonia's official tree. (Courtesy of Maurie Walker.)

No, this isn't the outskirts of a Native American community. This is Ford Field on Farmington Road, where Livonia's Department of Parks and Recreation Office was located.

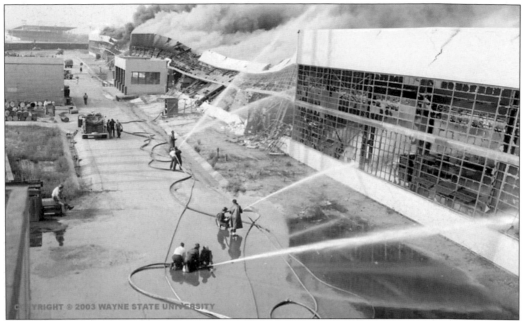

In 1948, General Motors constructed their Hydra-Matic Transmission Plant on Plymouth Road. It produced transmissions not only for GM, but for Nash, Kaiser, Hudson, and Lincoln as well. On August 12, 1953, the factory burned to the ground. At the time, it was considered the costliest fire to ever take place under one roof, with damage estimates somewhere around $80 million. (Courtesy of Walter P. Reuther Library, Wayne State University.)

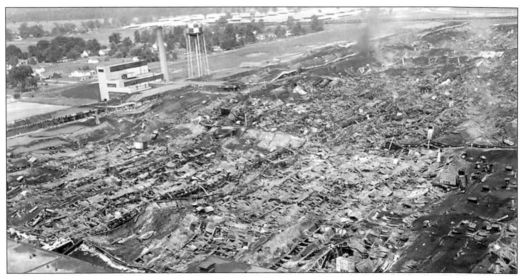

The fire began when a construction worker using an oxyacetylene cutting torch ignited a flammable liquid used as a rust inhibitor for transmission parts. The fire was almost contained with hand-held extinguishers, but those extinguishers ran dry. Within minutes, the fire raced through the 1.5 million-square-foot plant. While most of the 4,200 employees escaped with their lives, three workers died fighting the fire and one Livonia fireman died of a heart attack. GM subsequently moved its transmission production to the former Kaiser-Frazer factory at Willow Run. (Courtesy of Walter P. Reuther Library, Wayne State University.)

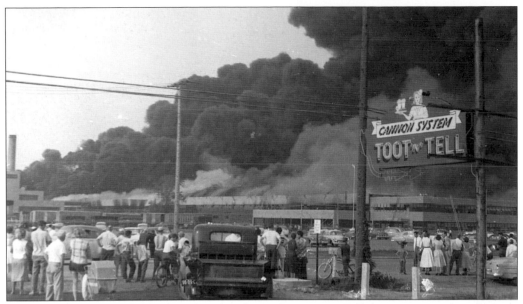

This view of the General Motors fire also shows the Toot 'n' Tell drive-in restaurant that was on Plymouth Road. A precursor to today's drive-thrus, patrons would "toot" their horns to get service, then "tell" their orders to the carhop or over the "Cannon System" speakers.

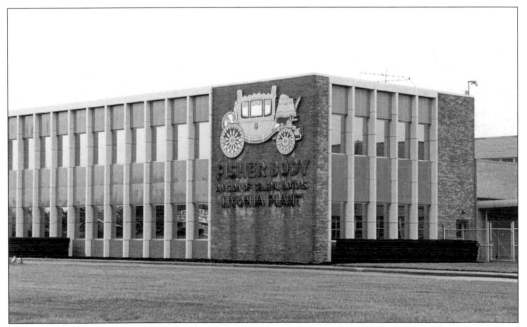

After the Hydra-Matic fire, GM rebuilt on the site and opened the Fisher Body Plant in 1954.

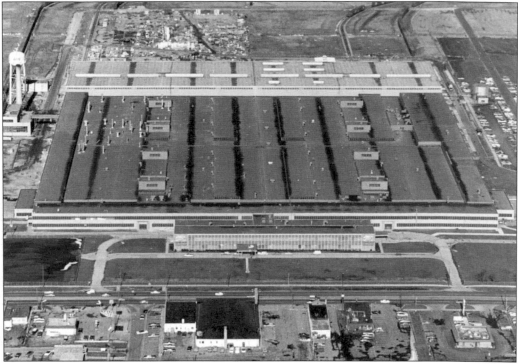

This aerial view of Fisher Body provides clear evidence of why Livonia was so popular with major corporations. Railroad lines could be literally run right up to the plants, allowing any kind of parts or goods to be shipped economically and efficiently.

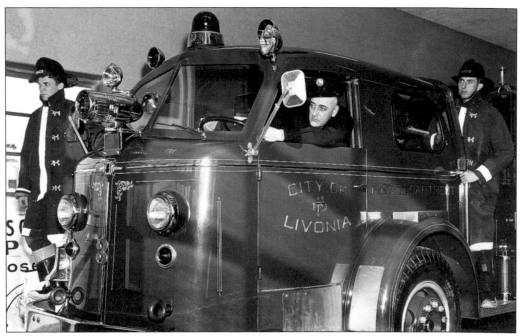

By 1954, Livonia had invested in two new American LaFrance fire engines, both of which were housed in the new fire station on Farmington Road just behind Shelden Center.

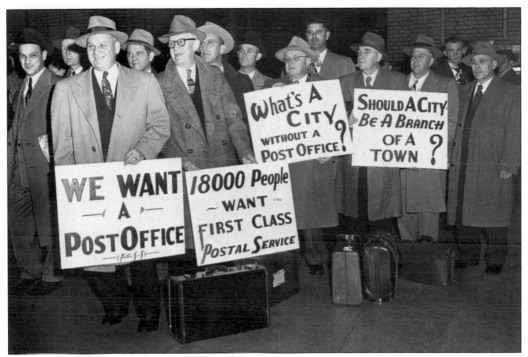

Livonia's version of an unruly mob gathered outside the Chamber of Commerce to make the point that as a city, Livonia should have its own post office (Livonia's official post office was located in Plymouth). Under such well-dressed and unrelenting pressure, the postmaster general announced in February of 1954 that Livonia would finally be granted its own post office.

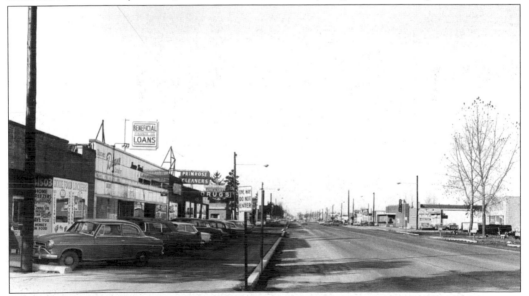

This is Plymouth Road west of Merriman in the mid-1950s. On the south side of the street, Dixie Food Lockers would not only process your freshly killed deer, they would also rent out freezers for storing food. On the north side of the street is Livonia Lanes, a bowling alley that has since been transformed into Eastside Mario's, an Italian restaurant. (The name Paul W. Gilbert appears on the back of this image, and is presumably that of the photographer.)

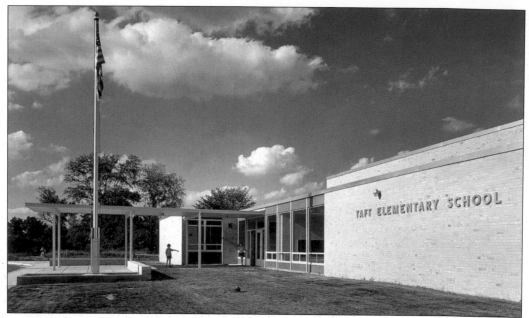

As more and more people poured into Livonia, more and more schools had to be built. The elementary schools were named for former U.S. Presidents, the junior highs for poets and philosophers (e.g. Riley [1957], Emerson [1958], and Frost [1963]), and the senior highs for statesmen (Franklin [1962], Stevenson [1965], and Churchill [1969]). Taft Elementary School, shown here, was opened in 1957. It closed in 1976.

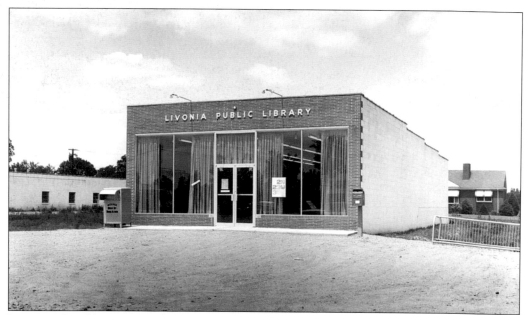

Livonia's first library opened on October 5, 1958 and was located on Plymouth Road west of Farmington Road. It held a grand total of 4,700 books. Anticipating America's need for drive-thru convenience, the box out front was an "Auto-Page Drive-Up Book Return." Angeline Rousseau, the city's first librarian, was also an accomplished musician and artist who had her artwork exhibited at the Detroit Institute of Arts.

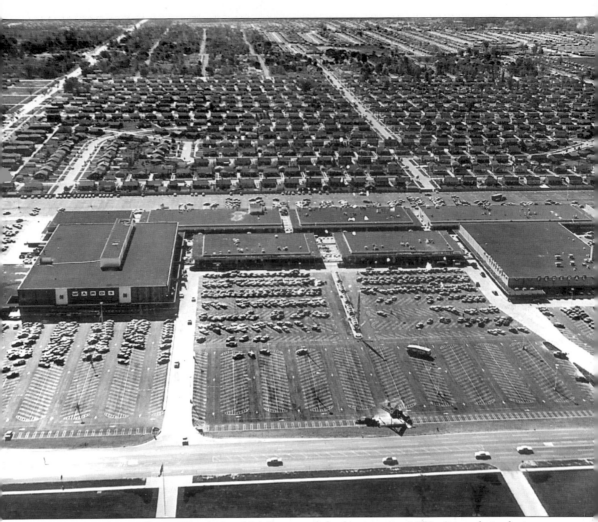

At a cost of $15 million, Wonderland Mall opened for business in 1958. A good-sized piece of land was required for the mall, so it was built on a former airfield known as National Airways Airport. It featured Montgomery Ward's and Federal's department stores, as well as Cunningham's, Winkleman's, and Hughes and Hatcher's. All told, the mall housed over 60 shops and employed over 2,000 people. Originally an open-air mall, it was redesigned to be completely enclosed in the late 1980s, but that decision failed to save the mall, which is closed and slated for demolition.

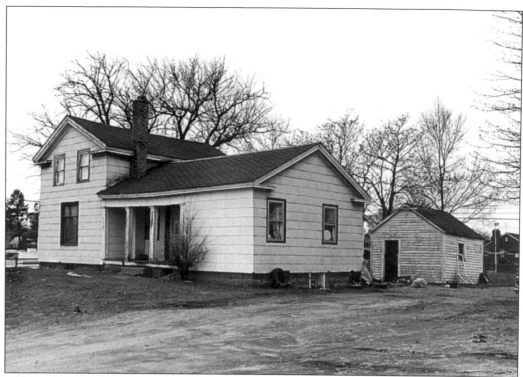

Old farmhouses like the McKinney home on Merriman Road (once known as McKinney Road) were starting to disappear one by one. Built in 1865, this house would eventually be torn down in 1975 and replaced with a Taco Bell.

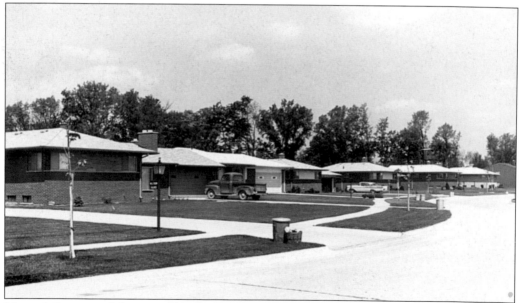

Meanwhile, new subdivisions like this one popped up all over Livonia in the 1950s. Typically consisting of ranch houses on lots 60 feet wide, these homes generally cost between $13,000 and $15,000 and their affordability helped trigger Livonia's jump in population. Only 17,534 people lived in Livonia in 1950, but by 1960 that number had leapt to 66,702.

# *Nine*

# 1960s

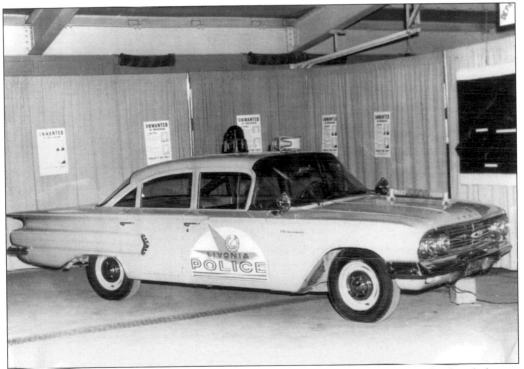

In 1960, this brand new Chevrolet Biscayne was the police department's vehicle of choice. That same year, there were 57 police personnel employed by the city.

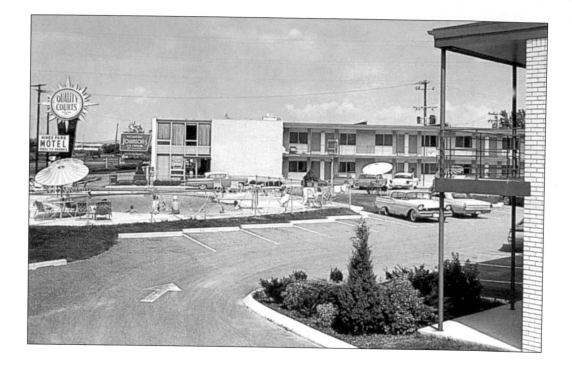

There were only three Livonia motels in the early 1960s: Hines Park Motel, Plymouth Motel, and Royal Motor Inn. The opening of the Detroit Race Course meant that there was a market for motels for both horseracing fans and horse owners. What is unusual is that even with DRC long gone, all three motels are still in operation today.

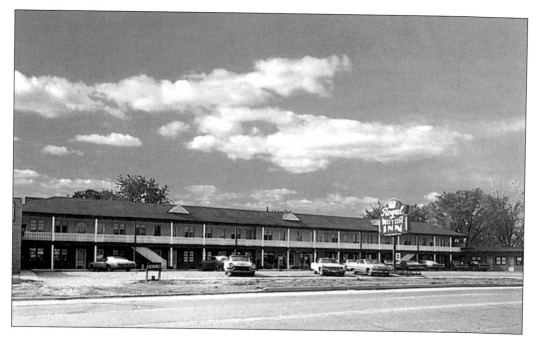

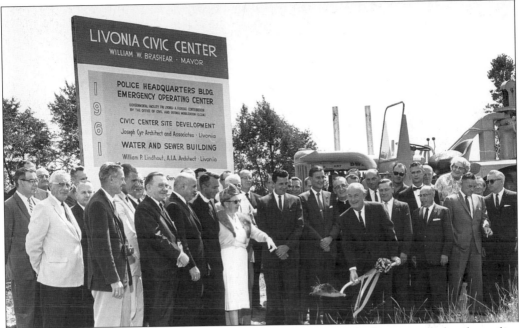

In 1961, Livonia broke ground on its Civic Center, an area which now includes the police station, a fire station, a senior citizen center, the 16th District Court, City Hall, and the Civic Center Library. Mayor Brashear does the honors with a ribbon-festooned shovel.

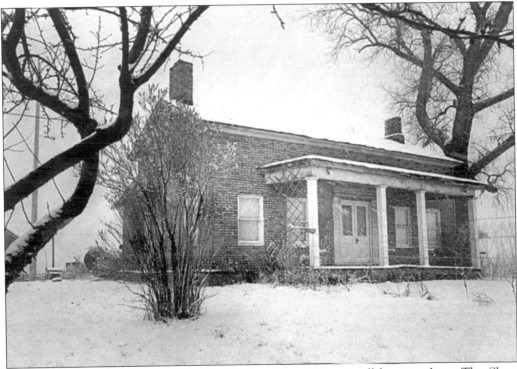

Even as new buildings went up, some relics from Livonia's past still hung in there. The Shaw House, dating back to 1843, would eventually be moved to Greenmead Historical Park in 1981.

Harvey W. Moelke was the mayor of Livonia from 1962–1970. In contrast to William Brashear's pro-growth philosophy, Moelke feared Livonia's quality of life would deteriorate if it grew too quickly, and he was firmly opposed to building too many houses or allowing apartments within the city. A go-go dancing bar on Plymouth Road was also shut down by Moelke. He retired to Florida, where he passed away on Christmas Day, 1990.

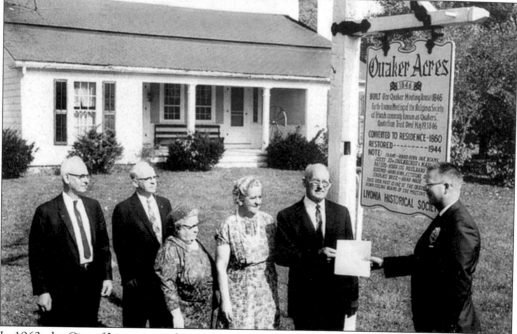

In 1962, the City of Livonia purchased the restored Quaker Acres. Here, members of the Livonia Historical Commission (established in 1958) pose with Mayor Moelke. The signpost was made from one of the original hand-hewn oak beams used in the structure. The joists of the building had been made from walnut and maple wood.

Noble Bates opened up his iconic burger joint on February 14, 1959. Over the years there have been many offers to buy this prime piece of real estate right in the heart of the city, but all have been refused and Bates is still going strong today. In a world of franchised, mass-marketed everything, Bates is still a restaurant where the employees and customers know each other by name. (Photo courtesy of www.jayasquini.com, ©J. Asquini.)

This is Wonderland Mall as it appeared in the 1960s. Stores at the time included Woolworth's, AAA Pet Shop, Rose Jewelers, Kresge's, and Wrigley's.

This Cunningham's Drug Store was in Shelden Center at the corner of Plymouth and Farmington Roads.

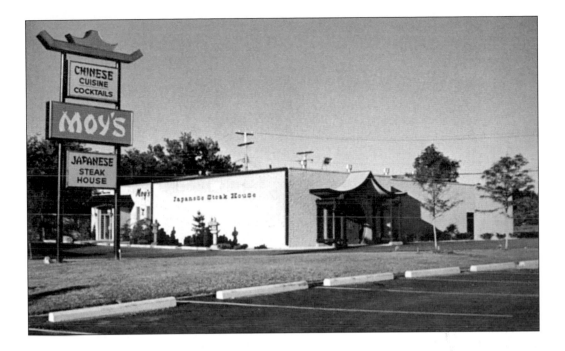

If you lived in Livonia in the 1960s, it's a good bet you ate at one of these restaurants. Moy's, located on Middlebelt Road, began life as Moy's Chop Suey Drive-In before reinventing itself as Moy's Japanese Steak House. The Livonian Prime Beef Buffet (formerly Stover's) was on Plymouth Road and promised "Prime Beef served to your satisfaction."

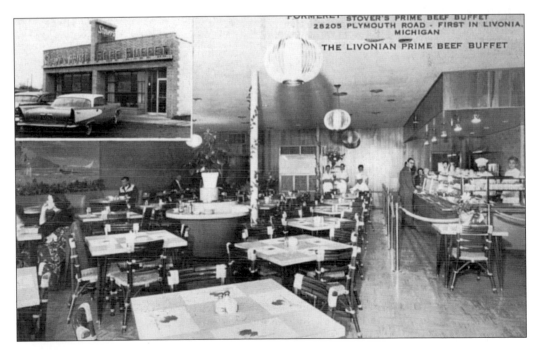

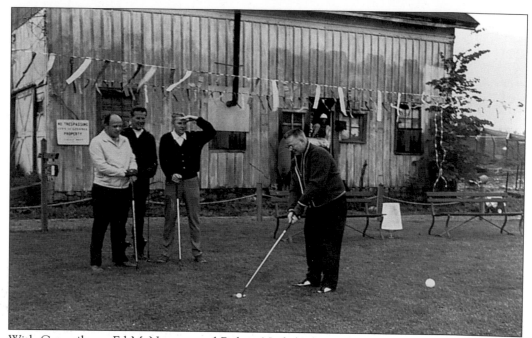

With Councilmen Ed McNamara and Robert Nash looking on, Mayor Moelke tees off at the new Whispering Willows Golf Course, which opened in the spring of 1968. Formerly the site of the Powers Cheese Factory, Whispering Willows joined Idyl Wyld as the second city-owned golf course.

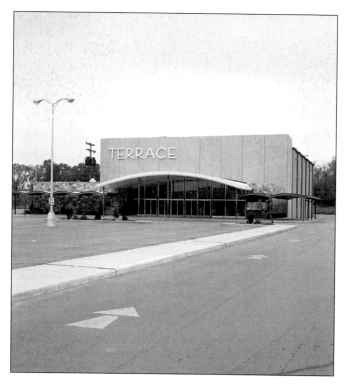

The Terrace Theatre opened on September 20, 1962 with a Super Technirama 70 version of *The Music Man*. Seating 1,190 and with a 59-by-27-foot screen, the theatre had been designed by Ted Rogvoy, who also designed the Penn Theatre in Plymouth and the Mercury Theatre in Detroit. By the 1970s the theatre had been split in half to become Terrace 1 and 2; then in the 1980s it was taken over by Cinemark and transformed into a quad theatre called the Terrace 4. The Terrace closed for good in 1999 and has been converted into a showroom for a local auto dealer. (Courtesy of Walter P. Reuther Library, Wayne State University.)

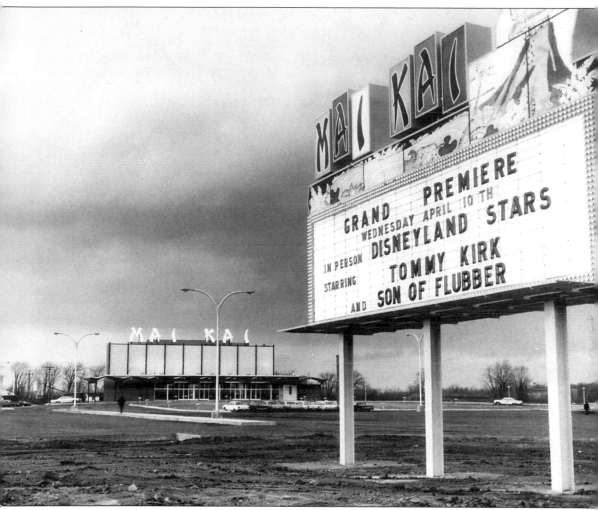

Livonia's Polynesian-styled theatre, the Mai Kai, opened in 1963. Built for over $1.5 million, it had 1,396 seats and a 60-by-27-foot screen. Opening night featured not only the film *Son of Flubber*, but stars Annette Funicello and Tommy Kirk were also in attendance, not to mention the Mai Kai orchestra, which performed only on this occasion. The Mai Kai closed in 1987, but reopened in 1988 as the Omni Star Theatre. This was a live performance venue that soon folded, only to be reopened once again in 1992 as the George Burns Theatre. (Courtesy Leo Knight Photography.)

The influx of baby boomers and their families meant that the Livonia Department of Parks and Recreation had a big job on its hands. Parks were built, outdoor ice rinks were created in the winter, and events like this kite-flying contest held in the parking lot of Wonderland Mall became increasingly commonplace.

Schoolcraft College opened in 1964 and was named for Henry Rowe Schoolcraft (1793–1864), the explorer and ethnologist noted for his discovery of the source of the Mississippi River and for recording the stories and language of the Ojibwa Indians while posted as an Indian agent in Sault Ste. Marie, Michigan. One proposal called for the college to be built at Six Mile and Farmington Roads, but its seemingly out of the way location on Haggerty subsequently gave the college plenty of room to expand. On a clear day, you can see buildings in downtown Detroit from Schoolcraft's soccer fields. (Courtesy of Walter P. Reuther Library, Wayne State University.)

On October 29, 1964, Livonia Mall opened its doors for business. Located at Seven Mile and Middlebelt Roads, it featured a Crowley's and a Sears along with approximately 50 smaller stores, including Sanders, Grinnell's, Singers, and Hot Sam Pretzels.

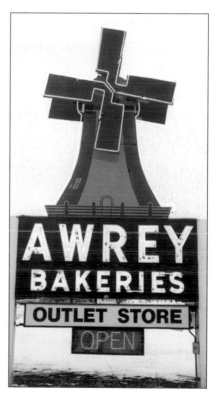

Awrey Bakeries was founded in Detroit in 1910 by Fletcher and Elizabeth Awrey. Their Livonia bakery opened in 1967 with the intent of producing only frozen bakery products while continuing to produce fresh bakery goods at their Detroit facility, but they soon realized they could handle everything at the Livonia facility and moved all production here in 1968. The company is still run by the Awrey family and turns out 125 different bakery products from five separate production lines that run approximately 20 hours a day.

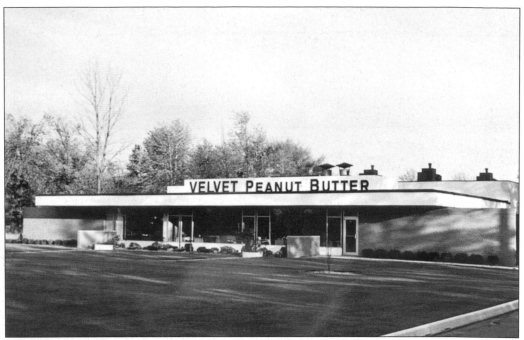

Velvet Peanut Butter was made at this factory on Schoolcraft Road, sending the pleasant smell of peanuts into nearby neighborhoods. Available in either creamy or crunchy varieties, it was advertised as being "Fresh," "Pure," and "Delicious."

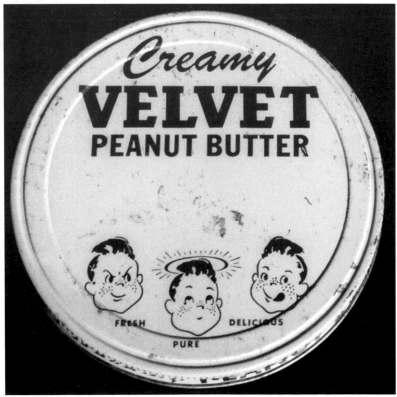

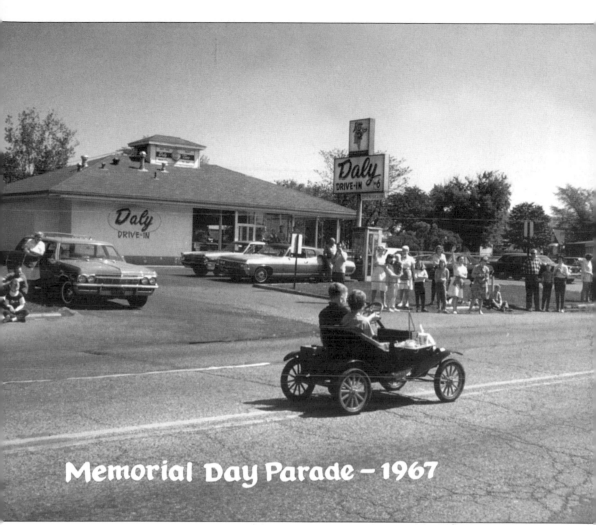

**Memorial Day Parade – 1967**

Daly Drive-In on Plymouth Road was opened in 1959 by Bud and Doris Grace. Today their son, Scott, runs the restaurant. Reminiscent of scenes in the film *American Graffiti*, patrons can still park and have their foot-long Daly dogs and Boston Coolers brought right to their vehicles. (Courtesy of Scott Grace.)

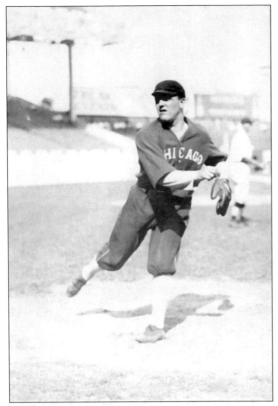

One of the most notorious sportsmen of the 20th century lived in Livonia for years. In 1919, Eddie Cicotte was the second-best pitcher in the American league, trailing only the immortal Walter Johnson. He was on track for a Hall of Fame career, but it was that same year that Cicotte and some of his Chicago White Sox teammates threw the World Series for money offered to them by gamblers. Subsequently banned from baseball along with the other "Black Sox," Cicotte wound up in Livonia, working for the Ford Motor Company and then running his strawberry farm on the north side of Seven Mile Road at Merriman Road. He passed away in 1969 and is buried in Livonia's Park View Cemetery.

There are few things sadder than a shuttered Han-D-Dip Dairy Barn in mid-January. But come March, it will open again as it always has since 1963.

# Ten

# 1970s and Beyond

It's fair to say that the size and appearance of Livonia's current City Hall would come as a bit of a shock to the early pioneers who came up the Rouge River looking for good farmland. The glass-skinned, five-story building opened in 1979.

This image shows Newburgh Dam and the former Henry Ford factory that was part of Ford's "village industries" plan. Ford had 18 similar sites situated along streams to make use of electricity generated by water power. This Art Deco building was built on the site of a former cider mill and was eventually acquired by Wayne County when the Ford Motor Company abandoned its village industry operations.

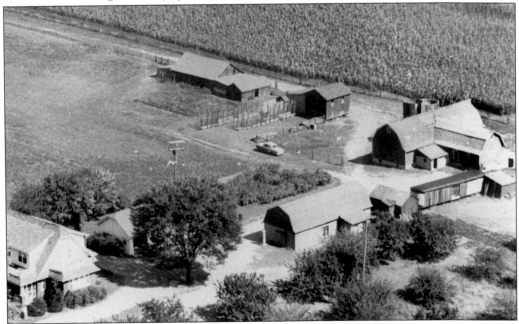

This is the Lute Farm as it appeared in the 1970s. On the east side of Newburgh Road and north of Seven Mile Road, all of its structures were torn down in the 1990s, as the last vestiges of Livonia's rural past disappeared one by one.

Edward H. McNamara was Livonia's longest serving mayor, holding the office from 1970 until 1987. The former councilman oversaw one of the most productive periods in Livonia's history before moving on to become the chief executive of Wayne County.

Beginning in 1973, the Livonia Spree held at Ford Field has served to commemorate Livonia's anniversary as a city. As any Spree-savvy Livonian can tell you, there is nothing quite like chowing down a few corn dogs and then going for a whirling ride 30 feet in the air. (Courtesy of the *Livonia Observer*.)

This is St. Mary Hospital at Five Mile and Levan Road as it appeared in the 1970s. Livonia's only hospital, it cost $3.5 million to build and opened on December 8, 1959 with only 175 beds. By 1972 the hospital had more than doubled in size and substantial construction and remodeling was completed in 1975.

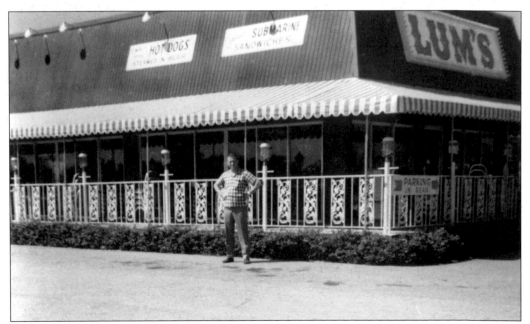

Livonia has seen any number of franchise restaurants come and go—Burger Chef, Red Barn, and Lum's among them. Famous for their "Hot Dogs Steamed in Beer," this Lum's was located on Plymouth Road across from the Terrace Theatre. Replaced briefly by the Clock Restaurant, the building has housed Archie's Restaurant since 1981. (Courtesy of George Palushaj.)

The I-96 Freeway, which runs from Detroit to Muskegon, goes right through the heart of Livonia. Constructed at a cost of $1 million per mile, it was dug into the median of Schoolcraft Road, a median that people used to picnic on and ride their horses down in earlier days.

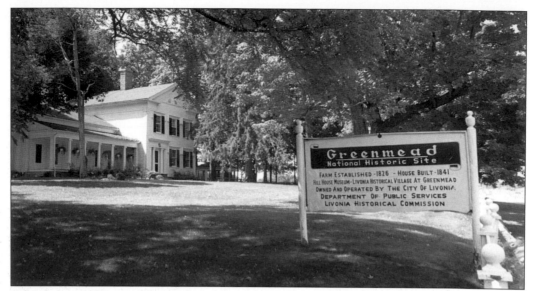

When inexorable progress threatened Livonia's historic buildings, many of them were moved to Greenmead Historical Park, where they have been preserved and restored so that future generations can see, touch, and experience the history of their city. The Quaker House, Geer General Store, Kingsley House, Newburg Methodist Church, and Newburg School are just some of the structures that have been spared the fate of being demolished.

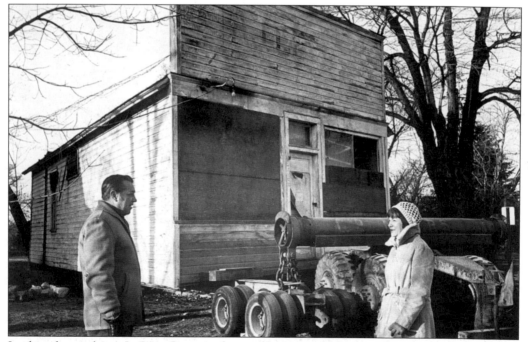

In this photo, the A.J. Geer Store is about to be removed from its foundation and taken to Greenmead Historical Park. Thanks to a bicentennial grant, both the A.J. Geer Store and the Newburg D.U.R. Depot were moved to Greenmead in 1976. Also pictured here are Chuck and Connie Wagenschutz, two of Livonia's leading preservationists, who contributed greatly to the restoration of a number of Livonia's historic buildings.

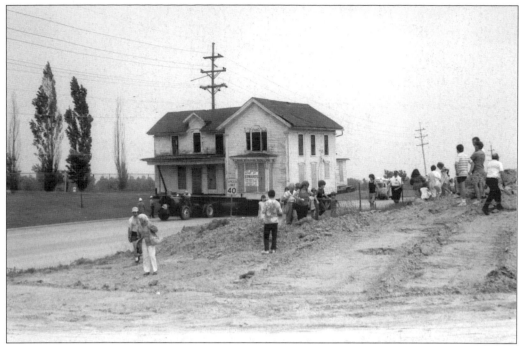

It's not every day you see a 19th-century farmhouse going down the road. But in May of 1987, the Alexander Blue House evaded the wrecking ball by taking Middlebelt Road to Six Mile, then heading west to Newburgh and finally ending up at Greenmead Historical Park, where it has been restored to the period of the 1880s.

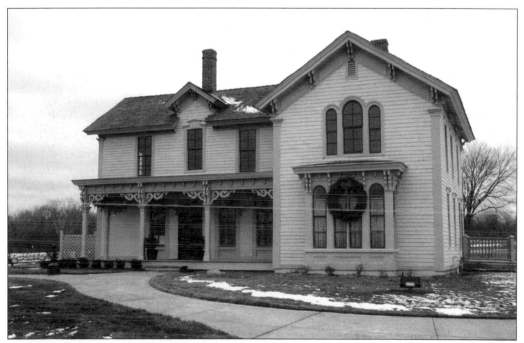

The Blue House is pictured at its new location. It took a lot of time, effort, and money, but the two-story Italianate farmhouse has been restored right down to its curvilinear gingerbread trim.

Its Polynesian heyday long since passed, the Mai Kai was purchased for $2.5 million and dubbed the George Burns Theatre in 1992. Miss Michigan Shannon Clark was there for the dedication on September 28. New road signs temporarily turned Farmington Road into George Burns Boulevard and Plymouth Road became Gracie Allen Road. With special guest Florence Henderson beside him, George Burns opened his namesake theatre on October 2. (Courtesy of the *Livonia Observer*.)

Despite such offerings as *Lettice and Lovage* starring Julie Harris, Andrew Lloyd Webber's *Aspects of Love*, and the comedic stylings of Jackie Mason, the theatre failed to generate sufficient revenue. In 2003 the theatre and its stylish George Burns sign were torn down and replaced by a drug store and the Fountain Park condominiums. (Courtesy of Kim Kovelle.)

Eddie Edgar Ice Arena is named for Wilson William "Eddie" Edgar. Starting in the 1920s, he was a sports reporter for the *Detroit Free Press* and then in 1964 began writing for the *Livonia Observer*. A Livonia resident for 48 years, he was one of the original councilmen in 1950 and a great supporter of sports and recreation within the city.

When the youth soccer boom hit, Livonia led the way in Michigan. The Michigan Wolves (boys) and Michigan Hawks (girls) are both based in Livonia and are routinely ranked not only the best soccer clubs in the state, but among the top 20 clubs in the entire country.

For years, Livonia had two libraries, the Carl Sandburg Library on Seven Mile Road, which opened in 1961, and the Alfred Noble Library on Plymouth Road, which opened in 1967. The considerably larger Civic Center Library opened in 1988.

Built on the former site of Bentley High School, Livonia's state-of-the-art Community Recreation Center opened in April 2003. Beyond standard amenities such as fitness equipment, a pool, and basketball courts, it also offers a 250-foot water slide, a 42-foot-high climbing wall, and an outdoor skateboard park. All in all, a place where pioneers like Salmon Kingsley, Phineas Wilson, and David Ryder might have enjoyed spending a few hours after finishing up their farm work.